The Tudor Image

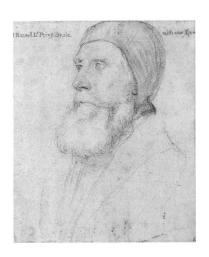

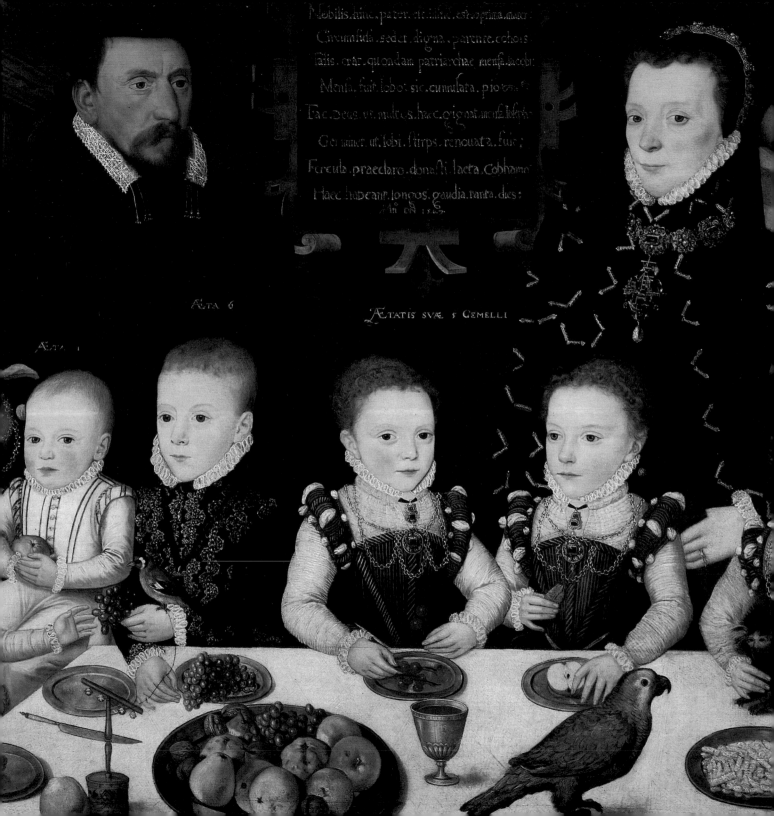

Nobilis hinc pater et illinc est optima mater
Circumfusa sedet digna parente cohors
Talis erat quondam patriarchae mensa Iacobi
Mensa fuit Iob: sic cumulata pio
Fac Deus ut multos haec gignat mensa fideles
Germinet ut Iobi stirps renovata fuit;
Fercula praeclaro donasti laeta Cobhamo
Haec habeant longos gaudia tanta dies:
An DN 1567

ÆTA 6

ÆTATIS SVÆ 5 GEMELLI

The Tudor Image

MAURICE HOWARD

TATE GALLERY

For Hugh and Hilary Kennedy

Author's Acknowledgments
Amongst many people at the Tate Gallery
who have made this book possible, I want to
convey special thanks to Celia Clear, Elizabeth
Einberg, Carlotta Gelmetti, Colin Grigg,
Karen Hearn, Richard Humphreys and Susan
Lawrie. Nigel Llewellyn, my colleague at the
University of Sussex, cast a critical eye over
my first outline for the text

Published by order of the Trustees by Tate Publishing Ltd,
Millbank, London SW1P 4RG
Designed by Roger Davies
© Maurice Howard 1995. All rights reserved
Printed in Great Britain by Penshurst Press

page 1
Hans Holbein the Younger
John Russell, 1st Earl of Bedford late 1530s
Black and coloured chalks on paper 34.9 x 29.2 cm
The Royal Collection. Her Majesty The Queen

page 2
(detail of no.37) British School
William Brooke, 10th Lord Cobham and his Family 1567
Oil on panel 91.7 x 120 cm
The Marquess of Bath, Longleat House, Warminster, Wiltshire

Contents

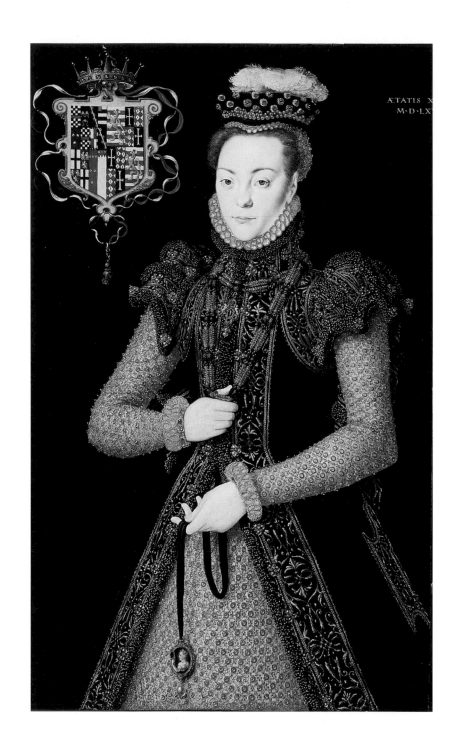

Introduction

1 Hans Eworth
An Unknown Lady c.1565-8
Oil on panel 99.8 x 61.9 cm
Tate Gallery, London

IN THE Tate Gallery, London, there is a painting of a richly-dressed woman of the Elizabethan period. Given its present location among a wide-ranging national collection of British paintings, someone encountering this picture for the first time in the late twentieth century might understandably want to form an opinion of its aesthetic value as a 'work of art'. How far does this painting strike us as successful in conveying a sense of the sitter as a real person, since a portrait surely has to fulfil the very obvious task of replicating likeness? Who was the artist and who is portrayed here? As we begin to explore the work, both by looking hard at it and by marshalling such evidence as we have of its origins, we find that not all of our questions are easily answered. We need different lines of enquiry to bring us closer to an understanding of the picture's meaning and function, one that comes to terms with the fact that sixteenth-century viewers, seeing it in the setting of a private house, would have had a very different set of expectations when they stood before such an image.

To begin with, they would not have encountered this picture by chance because only those who shared the woman's social class would have been privileged to see it. A portrait such as this would not have been made simply to be admired for its own sake. The making of a portrait was a rare and unusual event in the lives of the Tudor upper classes and, like all paintings of this period, would have been made to order. Portraits served the purpose of commemorating particular events which marked the stages of people's political and personal lives and, through funeral monuments, honoured their lives and marked their deaths. If this work marks such a milestone in

the sitter's life, was perhaps sent, for example, as part of negotiations about her marriage, then it is quite pertinent to wonder how 'real' or 'lifelike' the picture had to be. Perhaps the painting needed to be more concerned with depicting the sitter in accordance with contemporary notions of high social status or a suitable education. This might be most easily conveyed not by concentrating on the woman's specific facial characteristics but by subordinating these to a more general family likeness or alluding to her good connections by the inclusion of coats of arms.

In what sense therefore was it necessary to portray a convincing sense of space around her? How far does the woman in the Tate Gallery inhabit a world we can measure with our eyes and relate to the space around us? Though her face looks directly outwards, her body is posed at a three-quarter angle to the plane of the picture. We understand this not through any strong shadows cast across or by the figure, but through changes in the surface patterns of her clothes, such as the way the borders to her over-dress, splaying outwards to reveal the underskirt, are handled in different perspective to left and right. The way she lifts a jewel, representing Prudence, hanging from a ribbon at her waist, also lends a subtle indication of movement by suggesting an arrested action.

By contrast with the illusion of a figure turning in space however, the coat of arms at the top left and the inscription at the top right tend to emphasise the painting as a flat surface on which information about the sitter has been inscribed. It could be that this information is just as significant as her features, or certainly that the purpose of the portrait is incomplete

without it. Unfortunately, the riddles of the picture are not in this case solved by examining these clues for, like many paintings of this age, it bears the scars of time. The painting has been cut at some point on the right hand side, truncating the inscription with its roman numerals, so denying us the date in full and also her age. The coat of arms is not contemporary with the picture but was added in the seventeenth century, by which point the sitter's identity may have been lost; it may not therefore be accurate. Since the picture is not signed and is also undocumented before the nineteenth century, even the name of the painter is not known, though it is usually ascribed to the Antwerp-born artist, Hans Eworth, on the basis of stylistic comparison with other works bearing his monogram 'H. E'. Thinking about these ambiguities should make us aware of the painting as a physical object and how it has been vulnerable to change across time. Perhaps this sense of its physical nature can help us place it in the wider visual culture of the period.

In the sixteenth century, what we now think of as works of art, paintings we conventionally see in art galleries and country houses, formed a relatively small part of the visual culture of the élite classes. Though portraiture makes up the greatest single surviving category of portable pictures of this period, it was not as dominant at the time as we might suppose. Many other objects that surrounded the men and women of Tudor England carried visual imagery of other kinds. Tapestries or cheaper, painted cloths on the walls of houses showed narrative scenes from the Bible or classical history. Clothes and furnishings might bear heraldry or the personal mottoes or crests of their owners. Books carried woodcut illustrations or, increasingly common at this time, in the finer art of metal-plate engraving. Despite the coming of the Reformation and the ensuing suspicion of religious imagery, people would have continued to learn a good deal about the power of visual artefacts from the furnishings of the churches where they worshipped; the very presence of the royal arms, prescribed by the government, underlined state domination of the established church. Understanding visual meaning was very much a matter of context, even among portraits themselves; a portrait hanging in a public space, such as the council chamber of a town hall or the dining hall of a college at Oxford or Cambridge, would have had a different meaning from another hanging in the privacy of a bedchamber or a private study. Hence when we see these images of people in different sizes and formats we should think of them not just as likenesses but also as pieces of furniture, as a component of the ceremonial or private functions of their original locations.

What value did contemporaries place on their pictures? Not, we can be sure, value in terms of some notion of artistic worth, for they did not necessarily expect pleasure or stimulation from the act of looking, but in more practical ways. Surviving inventories of the period tell us that pictures were valued according to their size and the cost of their materials and, other than in a few royal and aristocratic inventories, named artists are rarely mentioned. Skill was valued not in terms of how far a picture was a successful counterfeit of the natural world but how well the materials of the work, paint or gold leaf perhaps, were handled and how much virtuosity was displayed

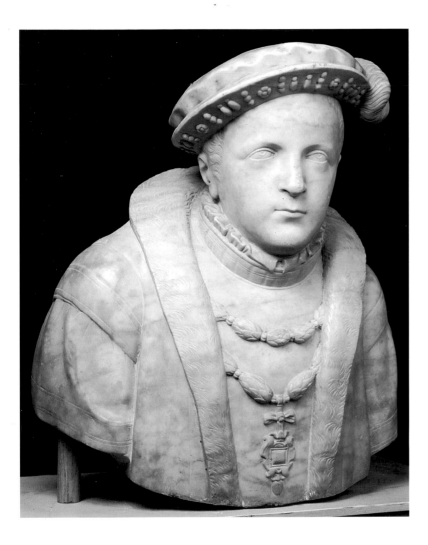

2 British School
Edward VI before 1590
Marble 61 cm high
The Earl of Scarbrough

as in 'the picture of King Edward' is widely used but can refer to a panel painting, or something from a range of objects in stone, marble, alabaster or terracotta. Panel paintings were often indicated by the use of the word 'table'. It was easier and more straightforward to use a term that described the act of making or the visual effect of an object; the conceptual terms we use today did not exist. Hence our understanding of the word 'sculpture' would not have been understood, but the physical activity employed in making a three-dimensional object could be described. A piece of sculpture made in metal, for example, might be described as a 'graving', the ancestor of our contemporary use of the word 'engraving' to mean incising on a metal surface.

For the purposes of this book, 'Tudor' is taken to include the works of those Jacobean artists who worked within many of the conventions of an earlier style of painting. This is not to argue, however, that the adoption of new styles in painting is the only way of understanding changes in the way pictures appeared. The Tudor 'style' is a collection of various means of depiction, each chosen for its appropriateness to place and function. The two assumptions of this book are that the original locations for pictures were important and that we need to explore why patrons wanted themselves shown in the way they are. These two paths of enquiry may help us break through the barriers of language and discover some of the purposes of making art in Tudor England.

in their use. Inventories have to be used by us with care because they are often not very specific about the things we want to know. Sixteenth-century people had only a rudimentary vocabulary with which to describe objects; many of the specialised terms that came into later use were not yet absorbed into the English language and other words lacked clarity or precision. The word 'picture', for example,

CHAPTER ONE

The impact of the Reformation: re-thinking the power of images

THE Reformation began with a political quarrel between Henry VIII and the Pope over the matter of the King's divorce from Catherine of Aragon and proceeded to unravel the whole structure of Roman Catholic belief and ritual among the people of Tudor England. How did this change the way people viewed objects around them at this time? The richness of the earlier visual culture engendered by religious devotion cannot be over-stressed. There had been an acceptance of the authority of the Roman Catholic Church that made England as obedient to Rome as any country in Europe. The great shrines such as that of Our Lady at Walsingham and of Thomas Becket at Canterbury had attracted many pilgrims each year and the talismanic objects of personal faith, such as small portable altars, books of devotion and rosaries, had been in everyone's hands. The vast number of objects to be found within church buildings and maintained by every parish for religious ceremonial had provided many surfaces on which imagery could be displayed; books, vestments, altar frontals, banners for processions, font covers. We can get a sense of the density and richness of this culture if we examine one of the late medieval chantry chapels that still survives. These small chapels, usually built by wealthy patrons in cathedrals or priory churches, were supplied with a priest, paid for by the patron, to pray for his or her soul and those of other family members after their deaths. Some of the last of these, like the chantry built by Lord de la Warr at Boxgrove Priory in Sussex in the 1520s show, through their adoption of the latest style of ornament copied from pattern books, how lively, current and fashionable this visual culture was.

The coming of the Reformation during the 1530s and the iconoclasm that followed in its wake has therefore been seen as particularly disruptive and destructive of the visual arts. The destruction which followed the suppression of the monasteries by Acts of Parliament of 1536 and 1539 have evoked through succeeding centuries an especially powerful impression of violence to the legacy of the religious past. Sacred buildings were defaced and pulled down and church assets secularised. In parish churches all over the country, imagery was removed as stained glass was destroyed or broken up, walls once covered with narrative cycles were whitewashed and altars torn down. Along with these changes, it has often been assumed that a medieval native tradition of art came to an end and that there is a kind of simple equation between the end of a market for religious imagery on the one hand and a rise in demand for portraiture on the other. Lacking the patronage of the church, painters, it is argued, must have turned to other sources of employment.

The true story of this process of destruction is more complex however. Recent historians have emphasised that there were several, sequential Reformations; the campaign of iconoclasm proceeded in fits and starts and was sensitive to changing political circumstances. More images and church furnishings may have survived the iconoclasts of the mid-sixteenth century than did the campaigns against images during the civil wars and republic of the 1640s and 1650s, and both these periods could be said to have been less destructive than the actions of Victorian developers of the nineteenth century. The pattern of conformity with the political decrees of the Reformation also

3 The De La Warr Chantry Chapel
1520s. Boxgrove Priory, West Sussex

varied according to which part of the country we take evidence from; large areas of the south of England accepted the reforms quite readily but in Lincolnshire rebellion in the form of the Pilgrimage of Grace of 1536 led to the government's ordering a systematic destruction of monastic sites in that county not seen elsewhere. Lancashire and Cheshire remained largely and covertly Catholic.

The government itself, having encouraged the pulling down of images at one point, found itself in the position of needing to defend parts of the church fabric. There was, for example, considerable alarm, prompting a government decree in 1563, about the way in which the removal of the imagery of saints in churches had led to the defacing of the tombs and monuments of the ancestors of the currently rich and powerful in society; this was seen to be highly subversive of the established political order. We do not know how many religious images from churches were squirrelled away into people's homes, where they were kept secretly for private worship. We do know that many people reclaimed from monastic foundations objects of value given by their ancestors. We should pause therefore and think about the implications of these changes. People did not forget overnight ways of observing and understanding religious imagery; in fact they brought those skills to ways of understanding meaning in other kinds of art.

It may surprise us to learn how inventories suggest that quite a lot of religious imagery remained in private houses for many decades after the first phase of the Reformation of the 1530s. What had changed, however, was the choice of content. By the end of the sixteenth century, we find very few instances of the de-

4 British School
Jephthah's Daughter
Oil on panel 41.9 x 185.7 cm
The Royal Collection.
Her Majesty The Queen

piction of the central mysteries of the old Catholic ritual, such as scenes of Christ and the Apostles, the life of the Virgin Mary, or completely spiritual concepts like the Holy Trinity. In their place people turned to the moralistic subjects of both Old and New Testaments, scenes which underpinned the value of Christian charity; many of the wealthy themselves aspired of course, by setting up almshouses and schools just as the medieval church had done, to ensure their own commemoration for posterity through charity. Also favoured for domestic interior decoration were the great set-piece battle scenes of the Old Testament, such as the story of Joshua. These could be associated with the valiant fight of an oppressed people against foreign tyranny, a useful parallel with England's confrontation of the might of Spain in the last quarter of the century. The story of Jephthah, from the Book of Judges, about a man returning to lead his people in battle, was the subject of a series of hangings recorded in 1575 at Lacock Abbey, Wiltshire, a dissolved nunnery which became a country house. A panel painting of about the same date, now in the Royal Collection, also explores this theme.

Parables from the Bible or local folklore, es-pecially tales of domestic life and personal relationships within the family, were also popular as subjects for wall paintings. These can still sometimes be found, often quite crudely executed, in modest houses belonging to the Tudor merchant classes, or at inns for travellers. Such subjects also found their way on to friezes or overmantels made in plaster or wood. By these means, old skills of telling and comprehending narratives were kept alive, no longer for worship and adulation but as exemplars of virtuous deeds and the punishment of sins such as idleness or infidelity.

One of the key means of making stories relevant to contemporaries was to include recognisable forms of dress. Moralistic scenes about everyday life might be portrayed in contemporary costume, whilst historical scenes from a legendary English past might be set in old-fashioned costume of two or three generations earlier as a way of suggesting to viewers that these people did once exist. Biblical stories were often depicted using a form of classical dress mixed with bizarre, exotic accents such as pointed hats or tall crowns. It is in this latter mode that the biblical scenes from the famous series of wall paintings at Hill Hall, in Essex, were carried out some time in the 1560s

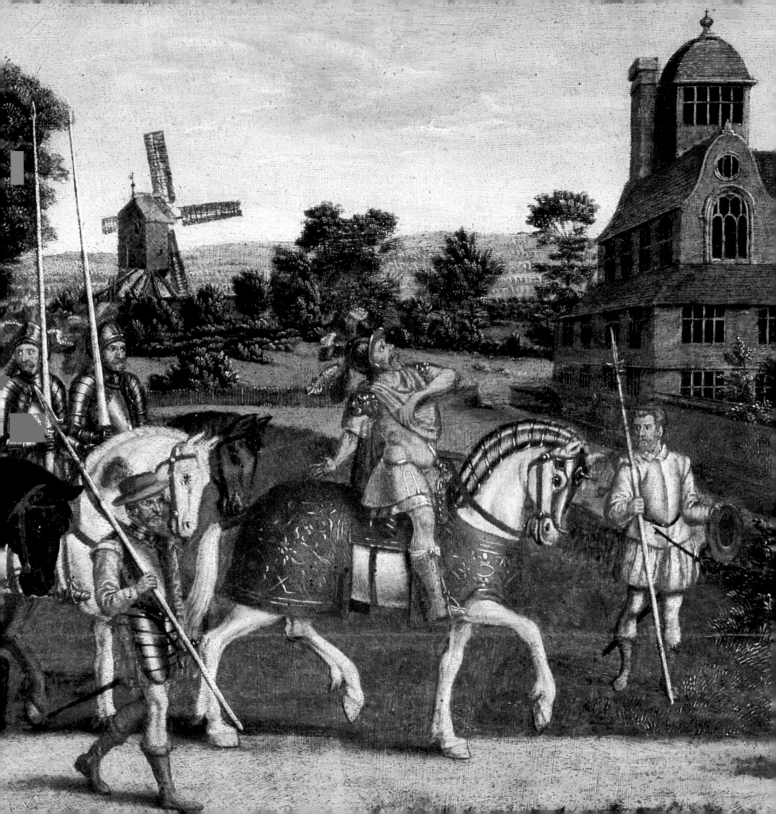

5 The 'Skimmington Ride' Plaster frieze, early 17th century, Montacute House, Somerset. In the tradition of decorating houses with moralistic narrative, this depicts the local custom of carrying a hen-pecked husband around the village as an object of derision. National Trust Photo Library

6 Wall painting of the story of King Hezekiah from the Old Testament, painted at Hill Hall, Essex in the 1570s (opposite)

and 1570s for Sir Thomas Smith, a leading statesman and at various times ambassador to France. Another room in Smith's house had a series showing the story of Cupid and Psyche with fictive borders of fruit and flowers; these borders have fringed edges, painted to look like wall hangings. These works have been shown to derive from Flemish prints, reminding us that the chief source for narrative art in this period came from prints and book illustration, the result of the burgeoning printing presses of the age which spearheaded the dissemination of new Protestant doctrine.

A key feature of these prints was the emphasis on re-inforcing the story with the text, just to be sure that it was politically correct for Protestant society. Telling stories defused any potential accusation of idolatry, usually associated with the single figure, because idols were different from, as an Elizabethan homily put it 'a process of a story, painted with the gestures and the actions of many persons, and commonly the sum of the story withal'. Some woodcut illustrations, such as those published by Gyles Godet of Blackfriars, are drawn in a highly sophisticated way using perspectivised buildings and landscapes. Most illustrations however were crudely done, with figures covering the sheet from top to bottom. This format, aided by the text, meant that the people of post-Reformation England were used to 'reading' images from left to right and up and down, gathering sequential information. They brought this technique of scanning the surface for meaning to the 'reading' of paintings of all kinds.

The Reformation itself had to be represented and given its own history for those of the reformed religion to remember and keep faith with. This function was performed most successfully in the woodcut illustrations to John Foxe's *Actes and Monuments*, popularly known as *The Book of Martyrs*. This was first published in 1563 and reprinted with new illustrations in 1570. Here the fate of the Protestant martyrs under Mary I were depicted with gruesome detail, as were the supposed sadistic practices of the Bishop of Rome and his henchmen. In addition, however, the new Protestant church itself had to be visually embodied as triumphant and cleansed of Catholic ritual and superstition; hence its portrayal, in the 1570 edition, as a simple, unadorned hall, with the faithful of the church shown no longer looking towards the altar but gathered around the pulpit.

This struggle against Catholic forces, who were believed to be poised for a counter-revolution, needed constant vigilance. A small panel painting generally known as *Edward VI and the Pope,* now in the National Portrait Gallery, London, is a rare survival of a painted image that conveys a particular religious and pedagogic message. It shows the young Edward VI being passed the responsibility for the reform of the Church by his dying father, Henry VIII. The prominent members of his Council of Regency are in attendance. Beneath his feet, the Pope is cast down and monks are evicted from their monastic way of life. The surface of the picture is covered with blank spaces, ready for inscriptions that for some reason were never placed here.

It used to be thought that this picture was painted at the time of the boy king's reign, about 1547 to 1549, but it has recently been discovered that this cannot be so. Crucial parts of the picture, including the scene at the top right where a collapsed building represents the old church order and the general disposition of the figure of Henry VIII in bed handing over authority are taken from prints after the Flemish artist, Marten van Heemskerk. The picture

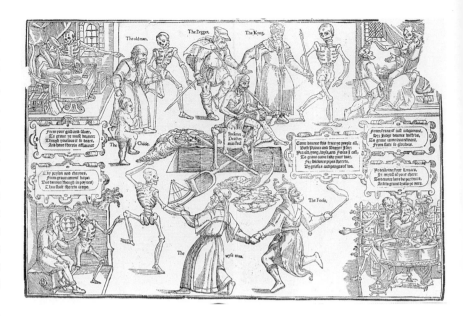

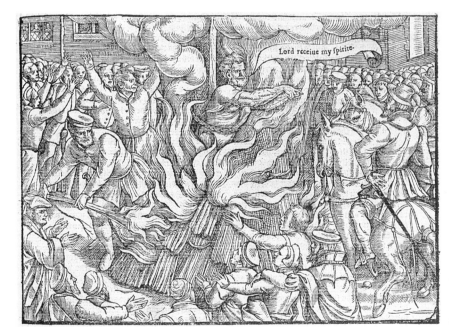

7 *Above* 'The Daunce and Song of Death'. Woodcut, printed by the ballad publisher John Awdeley of London in 1568-9. A ring of dancers is arranged like a diagram of images and texts to show the egalitarianism of death across all social classes. British Library

8 *Below* The burning of the Protestant martyr John Rogers in 1555. Woodcut from John Foxe, *Actes and Monuments* (1563). A polemical reminder of the cruelty of the former régime of the Catholic Mary I. British Library

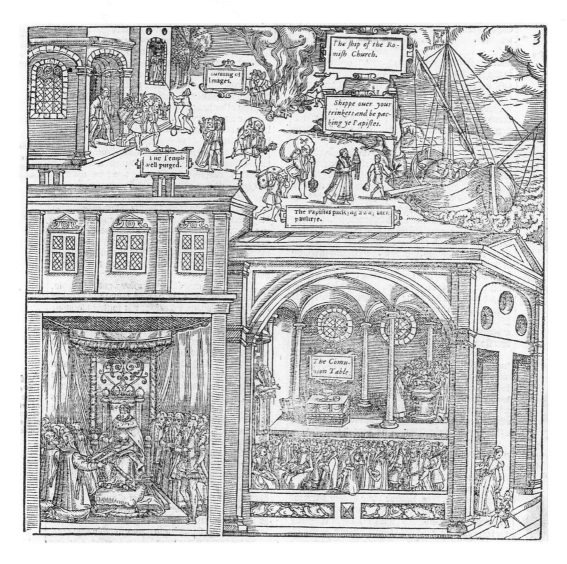

The labels visible within the woodcut read:

- The ship of the Romish Church.
- burning of Images.
- Shippe ouer your trinkets and be packing ye Papistes.
- The Temple well purged.
- The Papistes packing awai, and pauilirye.
- The Comunion Table.

9 The establishment of the true church. Woodcut from the second edition of John Foxe, *Actes and Monuments*, (1570). At the top, images are salvaged by Catholics whilst at bottom left the new church is shown as a simple temple, with worshippers gathered around the pulpit. British Library

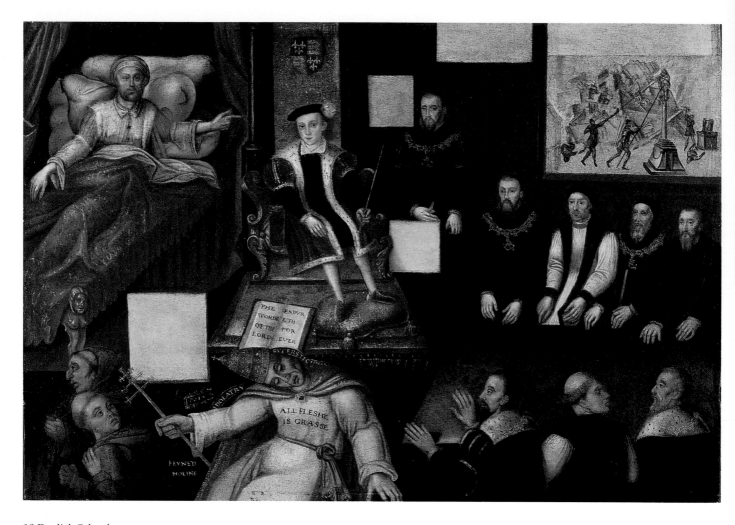

10 English School
Edward VI and the Pope: An Allegory of the Reformation c.1568-71
Oil on panel 62.2 x 90.8 cm
National Portrait Gallery, London

therefore cannot date before the end of the 1560s. The exact circumstances of its commission may never be known, but it has been suggested that this panel served to encourage Elizabeth I, who famously wavered in her attitude to the ritual paraphernalia of worship, sometimes demanding candles in her private chapel, sometimes sweeping them away, to be steadfast and support the continuing battle for reform. We can recognise from our own times the idea that revolutions initiated by the state need to be kept alive with new policies, thus keeping the faithful constantly active in the revolution's service. In *Edward VI and the Pope*, therefore, a highly programmatic piece of painting serves as religious propaganda.

Less overtly propagandistic but equally programmatic and more personal in character is the Tate Gallery's *Allegory* of about 1570. Where textual information is lacking on the small image of Edward VI, here we are faced by a plethora of texts, noticeably in English, as a kind of encouragement to the Protestant life. Most people would have absorbed the lessons of such an image from book illustration. It is not easy to judge how a small painting such as this would have been used. Images over altars were frowned upon but it could have found a place on the side wall of a small private chapel, or possibly kept, curtained or boxed as many small pictures were at this time, for the owner's private contemplation. The content underlines the Protestant's duty to seek salvation through leading the virtuous life, for the central figure is beribboned about with good Christian virtues. He is assailed from all corners by sin and temptation whilst a skeletal figure of death at the right reinforces the angel's message that all must be in order since death may come at any time.

Coming to terms with death was the principal aim of the monuments erected by the great in churches throughout the country. They tell us a great deal about the image of themselves that Tudor and early Stuart people had, because their commission and construction involved careful consideration of the memory of the deceased that was to be left behind. The securing of space for a grand monument was first of all about power. In Elizabethan and Jacobean England, leading courtiers jostled for precious space in the side-chapels flanking the chapels dedicated to Edward the Confessor and Henry VII in Westminster Abbey. The chapel of St Nicholas for example, is crowded with half a dozen tombs to powerful female figures at the court of Elizabeth I, including that of Mildred, Lady Burghley, wife to the Queen's chief minister. If on the other hand the parish church near the deceased's great country house was the site chosen for burial, that indicated something about power over the local community. Just as the family of the house had precedence in the church itself during services, so their monuments dominated the interior, often crammed against the high altar at the east end. Many great local landowners were of course newly rich from their buying up of land, and sometimes lived in adapted monastic buildings acquired in the wake of the Dissolution. It was especially important therefore that these people underlined their social position in the locality to show they were the equal of long-established aristocracy and gentry.

Many of the monuments we see in local churches today may strike us as highly elaborate and even garish, especially if they are

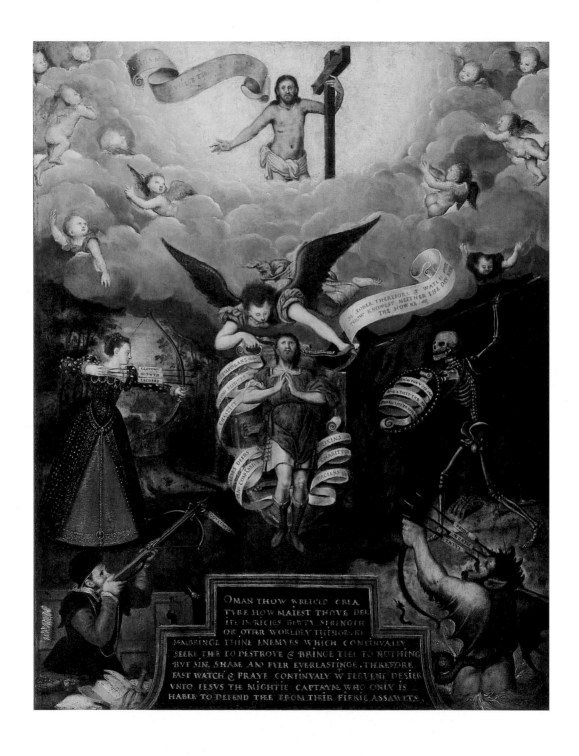

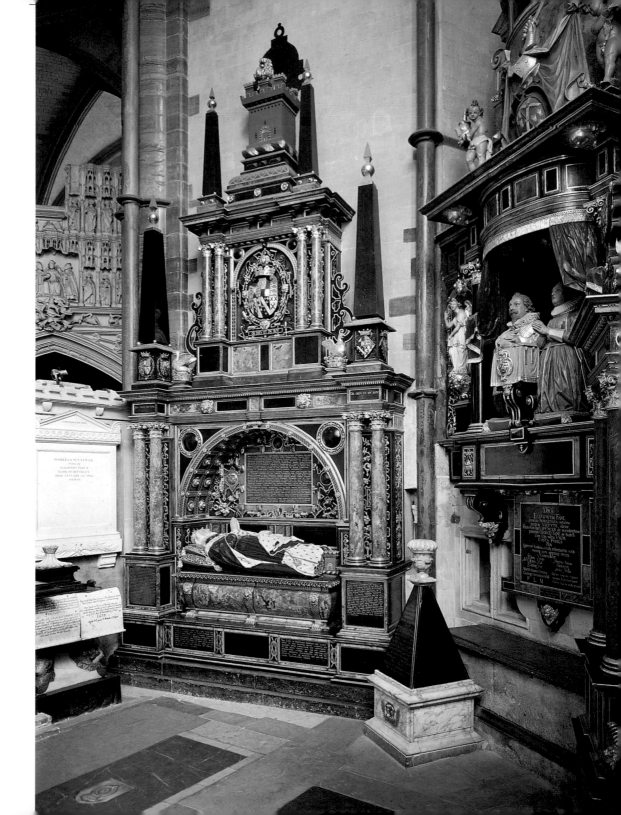

11 Anglo-Flemish
School (?Hans Eworth)
*Allegory of Man c.*1570
Oil on panel 57 x 51.4 cm
Tate Gallery, London

12 St. Nicholas's
Chapel, Westminster
Abbey, London.
A chapel crowded
with monuments to
powerful figures of
the sixteenth century,
including Anne
Stanhope (d.1587),
widow of the Duke of
Somerset who was
Protector to
Edward VI

made of different coloured marbles and are painted and gilded. Most have now lost the added accoutrements that would once have surrounded them; the ceremonial armour of the deceased hanging over the tomb perhaps, or banners that were carried at the elaborate funeral service. Some retain their original railings, put up to protect them. They often appear crowded with information and imagery; this is because they represent a complex and carefully composed celebration of the life of the deceased. At this period, death was seen as the culmination of life, the logical end of its progress, in a much more evident sense than we feel today. Preparation for death was essential because it could strike more suddenly, and at an earlier age for many, than is true in our own times. People often commissioned their tombs prior to their deaths. Others were paid for by their relatives; the role of women as 'art patrons' in this context, as the devisers of their husbands' monuments, has only been seriously studied in relatively recent times.

Negotiation with the presence of death in life had to be rethought with the Reformation. Prior to this, the belief was that souls entered purgatory to await the Last Judgment; hence the point of having masses said in the chantry chapel if you were wealthy enough to afford one. The Protestant faith allows no such intercession; your claim to a place in heaven is determined by the quality and goodness of your life on earth. Hence it was important that your virtuous life and your public deeds were celebrated on the monument. Imagery, in the form of figures of saints or Christ on the cross, were now of course forbidden; what took their place was the imagery of family position through heraldry, explaining important family connections, in some cases with more than one husband or wife. The significance of the family as a power base, as a means of buying in to other great families, is also present through the representation of children. Finally, long inscriptions discuss often only briefly a commendation of the deceased to God but then discourse at length on worldly achievement: offices of state, victories in war and scholarship when men are commemorated; for women, virtuous living, self-sacrifice and the production of children.

In the first half of the sixteenth century, the most common form of monument was the free-standing tomb chest. This gave place in later Tudor and Jacobean times to the great canopied monuments, sometimes free-standing between the choir and side-aisle, but often attached to the side wall of the church. The physical remains were placed in the vault beneath; what is represented through the effigies of the deceased is what has usefully been described as their 'social body'. This depiction of the dead in a state of quietude and contemplation both summarises the achievement on earth of a good Christian life and assures the beholder that the social fabric, which the living have a stake in preserving, goes on. The terror of death, the unknown, is thereby neutralised. Effigies on monuments wear their finest clothes and their features are fairly generalised to show them around the time of their prime of life. They are not therefore necessarily accurate representations of the physical appearance of these people but, like other kinds of portraiture of the period, they do mark an important stage in life, in this case the stage where that life's work needs to be set down to enable the living to remember.

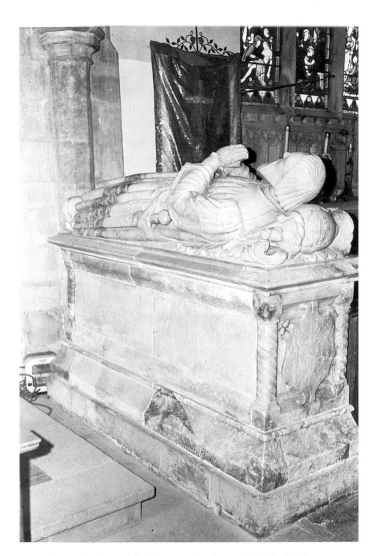

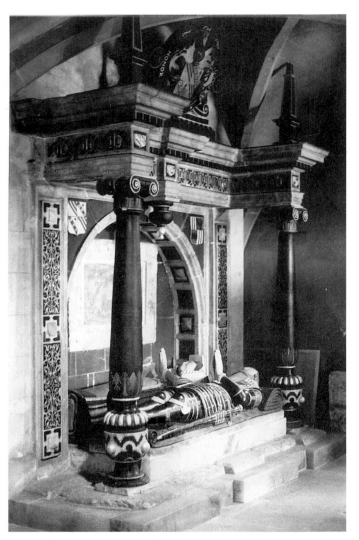

13 *Left* Tomb chest of Sir Thomas Tresham (d.1559), Rushton Church, Northamptonshire. The alabaster effigy wears the dress of a Lord Prior of the Knights Hospitallers, a holy order revived by Mary I

14 *Above* Tomb of Sir John Byron (d.1604). This typical example of a late Elizabethan wall monument originally stood in Colwick Church, Nottinghamshire, but was later removed to the undercroft of Newstead Abbey, post-Reformation home of the Byrons

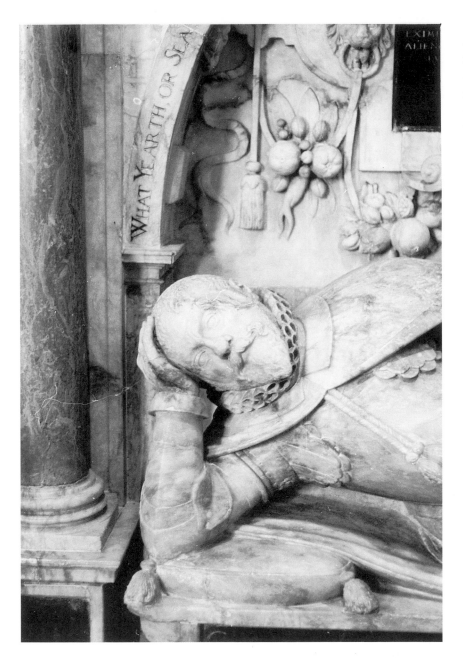

One other factor also influences the appearance of these effigies and their likeness to the individual. One of the most important consequences of the Reformation for the visual arts, in the face of the potential accusation of idolatry, was a nervousness about all forms of representation. Criticism of figures of saints and the way they were worshipped in pre-Reformation days centred on the mistaking of the image for reality. In the worst instances, gleefully reported by the royal commissioners when they visited monastic churches, images of saints wept or shed blood by artificial means to hoodwink the faithful. Images, it was argued by their critics, should at best simply prompt a religious devotion and a means to that end, not things to be worshipped in themselves. After the Reformation, therefore, patrons demanding visual objects of all kinds, but particularly representations of themselves, must have been conscious of the need to ensure that the information conveyed was convincing and unambiguous, but not so realistic as to invite the charge of idolatry. This is a salutary warning to us, when we discuss art of this period and look for the advance of sophisticated techniques, such as perspective and the consistent use of light sources in paintings, that some would have known all too well the power of verisimilitude these techniques could lend, but resisted their persuasion.

15 Detail of the tomb of Sir Thomas Smith (d.1577) in Theydon Mount Church, Essex. Diplomat and scholar, Smith was the builder of Hill Hall (see wall painting from there, fig.6)

Art in the making: techniques, materials and the social status of the artist

HOW WERE art objects made at this period and under what conditions did artists work? How far did their reputation spread and so increase their status and earning power? We think of the Renaissance in Europe as a time when the fame of great artists spread beyond their native countries and when their social status was increasingly enhanced. The Renaissance began in Italy and particularly in the highly competitive city of Florence, because that was where the potential of the visual arts as a fulcrum for intellectual discussion was supported by a growing literature about art and artists. Writings on art attempted to raise the status of the artist above that of craftsman. Giorgio Vasari's *Lives of the Artists*, published in 1550 and revised in 1568, told the recent history of Italian art as a series of biographies of artists who achieved ever-greater ambitions. A very few, like the Venetian artist Titian, commanded such respect that they could shun royal courts when they felt like it. Many had to be in constant attendance on the powerful and do their bidding, which meant at some times painting easel pictures, at others fulfilling the role of jack-of-all-trades, painting images or simply decorative ornament over the lath, wood and plaster of the latest temporary setting for court ceremonial and receptions.

In England, artists by and large enjoyed only lowly status. Only a handful of foreign artists working at the court ever achieved anything close to the position of some of their European counterparts. From 1502, registered painters in London were members of the Painter-Stainers Company , uniting the trade of painting on panel with that of the skill of making painted cloths for domestic wall-hangings. By the end of the century, panel painters were dominant, for the fashion for stained cloths had all but died out. When John Stow mentions the Painter-Stainers' Hall in his *Survey of London*, published in 1598, he notes that 'now workmanship of staining is departed out of use in England'. A proclamation of 1563 gives us some insight into the status of artists relative to other workers in terms of pay and conditions. Painter-stainers are recommended to receive £4 per year with meat and drink; this was less than carpenters, joiners and embroiderers (about £5 per year) and only half the remuneration of goldsmiths (£8).

Painters at the Royal Court could earn far more, but even here the chance to specialise was often difficult to secure. The Florentine Pietro Torrigiano, who came to Henry VIII's court to make the tomb of the king's father, Henry VII, for Westminster Abbey, specialised in sculpture in cast bronze and terracotta. Many other Italians in England, however, are recorded as working on a variety of tasks. The Florentine, Antonio Toto del Nunziata, was painting at Court by 1530 on an annual retainer of £25 and was granted denizenship in 1538. He indeed carried out 'dyvers tabulls' (tables, or pictures) of religious subjects for the King, but was also employed on heraldic painting for royal funerals and coronations as well as other temporary constructions for royal occasions. Girolamo da Treviso, who probably trained in Venice and had been a painter of altarpieces in Bologna, seems to have been employed by Henry VIII for his skills in composition; he was responsible for the small panel of *The Four Evangelists stoning the Pope*, now in the Royal Collection. He died however at the siege of Boulogne in 1544, probably serving as a military engineer. The Serjeant-Painters to

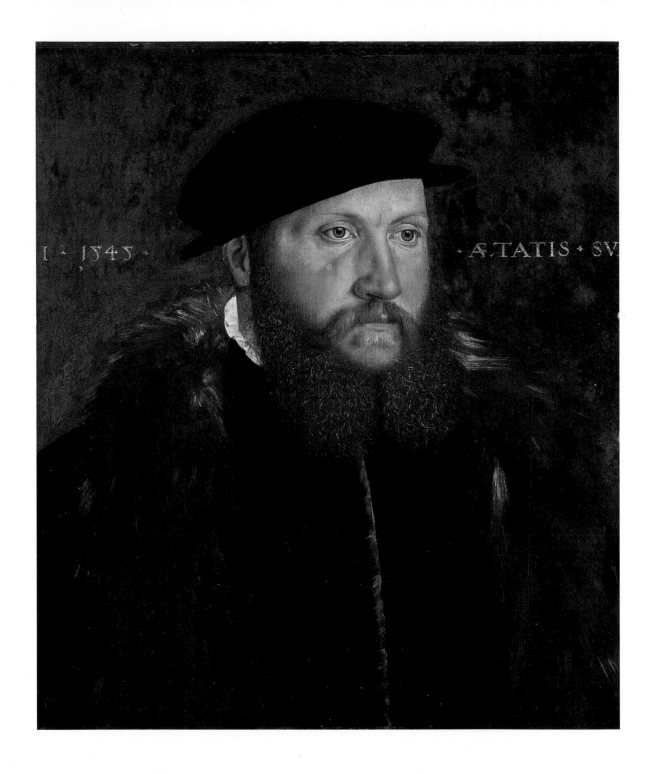

16 John Bettes the Elder
Man in a Black Cap 1545
Oil on panel 47 x 41 cm
Tate Gallery, London

Elizabeth I, like George Gower, painter of the most famous version of the 'Armada' portrait of the Queen, now at Woburn Abbey, spent some time on portraiture, but much more on supervising decorative painting, some of it restorations of earlier work, in the royal palaces. The appointment of John de Critz as joint Serjeant-Painter with Leonard Fryer in 1605 gives us a good insight into the duties expected for they are to paint, by James I's order 'our ships and barges and "close barges", coaches, chariots, carriages, litters, wagons and "close carres", tents and pavilions, heralds' coats, banners, trumpet banners, also painting in connection with the solemnization of funerals in any way belonging'.

Yet there is evidence that certain individuals did command particular admiration and were celebrated for what they were particularly good at. Even on his first visit to England in 1526-8, Hans Holbein was employed for prestigious pictures for the temporary building set up at Greenwich to receive the French Embassy of 1527; for this and other work at Court he was very highly paid. When he settled in England in 1532, his increasing specialisation in portraiture, and his drawings for royal commissions such as jewellery and goldsmith's work, underlined the special position he had attained. Specialisation could have its rewards; the artist John Bettes was quite a lowly-paid craftsman at Whitehall in 1531-3 but may have raised his status by learning to paint portraits in the Holbein manner so that when Holbein died in 1543 he could take over something of his role, as witnessed by the Tate Gallery's portrait *Man in a Black Cap* of 1545.

The great majority of portable sixteenth-

century English paintings that have survived are painted in oil on oak. The principal guidelines of this technique were inherited from the most influential school of oil painting in Northern Europe of the fifteenth century, the painters of the Low Countries; hence the long tradition, lasting well into the seventeenth century, of the employment in London and at Court of painters from this source. The carefully prepared ground and the smooth surface achieved on the panel allowed for fine underdrawing, initiated from a cartoon or, as has recently been established in the Bettes portrait, freehand. The colours were then meticulously applied, appropriate for the detail required. Recent technical examination of sixteenth-century pictures for English patrons has shown however that technical processes varied widely from one workshop to another, though some intended effects were common. Several artists, for example, experimented with smalt, a far less expensive blue pigment than the precious and valuable ultramarine, to achieve the blue backgrounds so favoured by patrons at this time. In most cases, the pigment has faded, giving many portraits neutral grey or brown backgrounds.

The use of panel as support took a long time to change. Most of Holbein's work, including the great full-lengths of *The Ambassadors* and *Christina of Denmark, Duchess of Milan* in the National Gallery, are on panel. Even in the 1570s, the full-length of *Frances Sidney, Countess of Sussex* was painted on panel. Oil on canvas allowed for a greater flexibility of technique and so became more usual by 1600, and even the artists whom we consider as still in the Elizabethan tradition of detailed, meticulous portraiture, such as William Larkin, were,

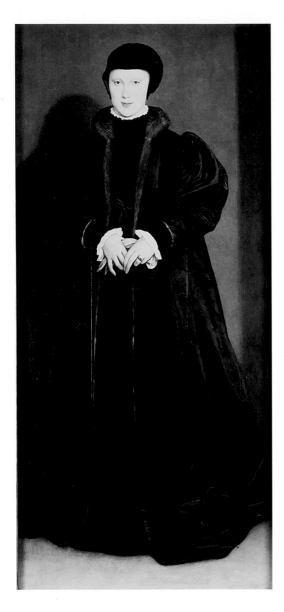

by the 1610s, using canvas. With this greater flexibility came less dependence on careful preparation for painting both on the surface of the support itself and in the tradition of careful drawings through which the artist sorted out his ideas. By the time we get to Van Dyck, we see how in this artist's hands the resolution was worked out on the canvas itself, so pressurised was he by the courtiers of Charles I to produce a great number of portraits at the same time. Van Dyck was therefore economical with his preparation time, securing a general impression through sketches on paper but leaving details until the finished painting. As Edward Norgate, an illuminator and manuscript painter who had known the artist in Italy and who lodged him when he came to London, observed: 'the excellent Vandike, at our being in Italie was neat, exact and curious, in al his drawings, but since his cominge here, in all his later drawings was ever juditious, never exact'.

Our knowledge of the processes of creating portraits is fragmentary. We know of one celebrated instance of Holbein at work with a sitter, for he was given three hours with Christina of Denmark in Brussels in 1538 to take her likeness for the portrait now in the National Gallery. Holbein would have drawn her and perhaps made colour notes for the painting he would create in his London workshop; notes about colour of costume and jewellery are found on many of his surviving portrait drawings. In quite a number of instances, Holbein used his portrait drawings as cartoons, that is to say the outlines were pressed on to the panel by means of a stylus and some sort of paper between drawing and panel that served in much the same way as modern car-

17 Hans Holbein the Younger
Christina of Denmark, Duchess of Milan 1539
Oil on panel 179 x 82.6 cm
National Gallery, London

29 Hans Holbein the Younger
A Lady with a Squirrel and a Starling 1526-8
Oil on panel 56 x 38.8 cm
National Gallery, London

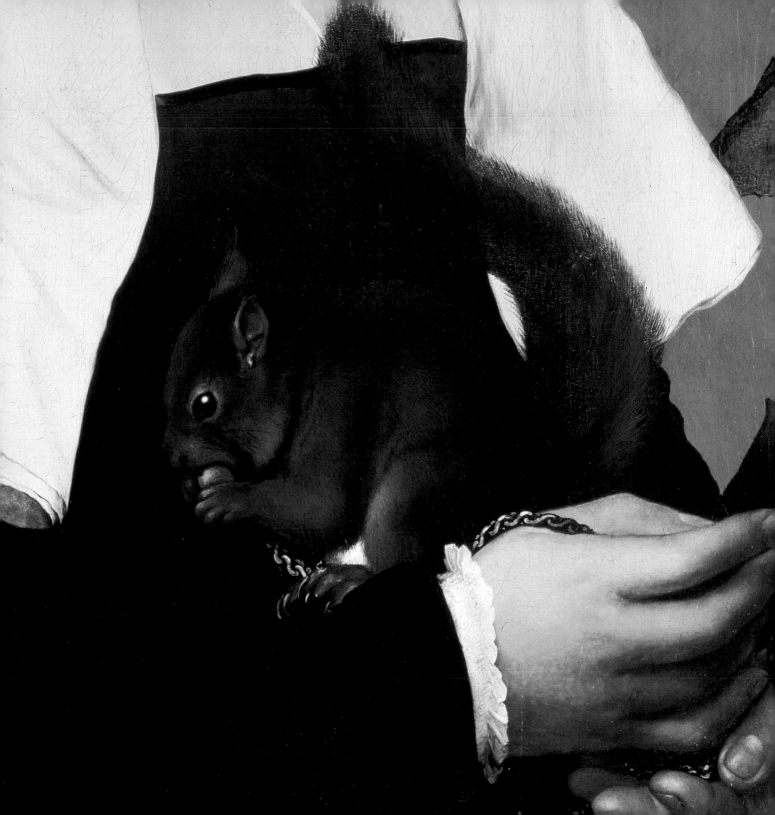

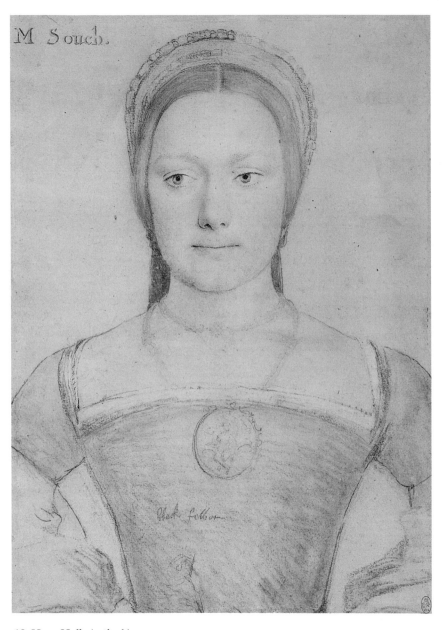

18 Hans Holbein the Younger
Mary Zouch
Chalk and ink on prepared paper 29.4 x 20.1 cm. The Royal Collection. Her Majesty The Queen
Holbein has made the colour note 'black felbet' (velvet) on the dress

bon paper. Even so, Holbein often changed significant details in the final painting, erasing facial blemishes or, crucially, altering the direction of the gaze.

Our richest source of knowledge of practice comes from the small body of technical instruction contained in treatises on painting. Notable among these are Richard Haydocke's 1598 translation of part of the Italian Lomazzo's treatise of 1584, the miniaturist Nicholas Hilliard's *The Art of Limning* (the word conventionally used for miniature painting), which remained unfinished and unpublished at his death in 1619, and Henry Peacham's *The Art of Drawing with a Pen* of 1606. The art of miniature painting was of course a highly specialist craft but Hilliard's manuscript brings us very close both to the exercise of that skill and the pretensions to status and good working conditions that went with it. It is a far cry from what must have been the busy, cheek-by-jowl conditions of the average painter in royal service. Hilliard insists on the painter working in a dust-free environment, necessitating that the artist wear only silk to deter the adhesion of dust to his clothes, and he lays down the need for great care and sensitivity in the procuring of the best colours and brushes. The painter should work in a room 'where neither dust, smoke, noise, nor stench may offend, a good painter hath tender sense, quiet and apt, and the colours themselves may not endure some airs, especially in the sulphurous air of sea-coal, and the gilding of goldsmiths'. The word 'miniature' comes not from the size of the object as one might imagine but derives from the word *minium*, the white lead which formed the ground for the colours. Hilliard describes how the technique

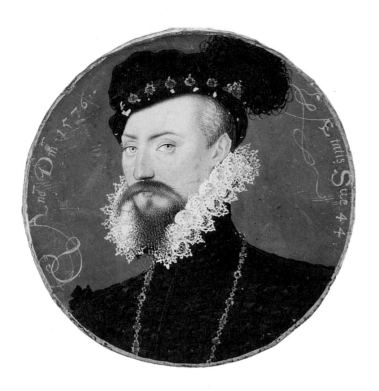

19 Nicholas Hilliard
Robert Dudley, Earl of Leicester 1576
Vellum on card, diameter 4.4 cm
National Portrait Gallery, London

consisted of painting on parchment which had been pasted on to card, usually fragments of the plain white sides of playing cards. This was necessary to support the miniature as object; otherwise the techniques of miniature painting in sixteenth-century England are very close to those of Flemish manuscript painters of the fifteenth century.

If it seems that Hilliard implies that the skill of miniature painting should of itself lend the artist gentlemanly status, then Peacham takes this a stage further by suggesting that instruction in the art of drawing with the pen was a suitable task for the education of young gentlemen, thus raising the status of art in polite society. Peacham also sought to raise the status and reputation of the native-born English artist, concerned as he was that 'our courtiers and great personages must seeke farre and neere for some Dutchman or Italian to draw their pictures, and invent their devises, our Englishmen being held for *Vaunients* [literally, worthless things]'.

Resentment against foreign-born artists surfaced from time to time as it did against foreigners in all trades. During the reign of Henry VIII, his successive Serjeant-Painters, John Brown and Andrew Wright, also succeeded each other as head of the Painter-Stainers Company and may therefore have attempted to stem the numbers of foreign artists at Court. In the second half of the century, refugees from the religious wars in the Netherlands boosted the numbers of foreigners heading for London. They were forbidden to live within the boundaries of the City and so it was in Southwark, south of the river, that we find the most successful workshop for tomb sculpture of this time, that of Garret Jansen, anglicised to

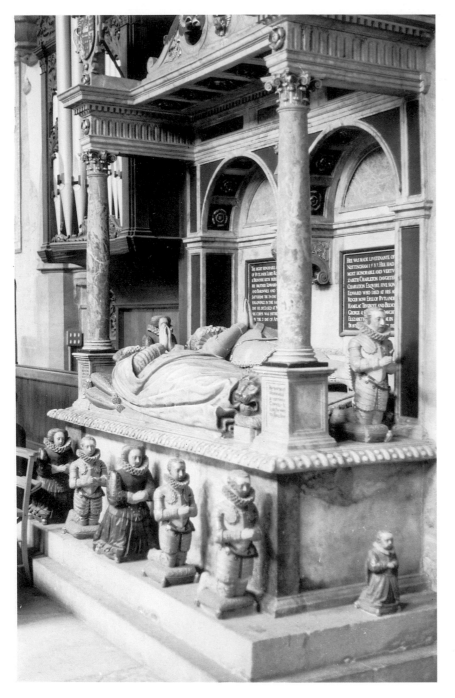

Gerard Johnson, who came to London from Amsterdam in 1567. As with many artists' workshops that were essentially businesses, pressure on the family to participate was strong and two of Johnson's sons became sculptors. The workshop was responsible for tombs commissioned by the fifth Earl of Rutland for his father and uncle, the third and fourth earls, which were set up at Bottesford on the borders of Lincolnshire and Leicestershire in 1591. The two tombs are basically of the same format, the only difference arising from inscriptions and subsidiary, attendant figures. We know that the work of carving the material, in alabaster and some expensive imported materials, was done in London and the component parts were then shipped to Boston, in Lincolnshire, and carried thence to the church in fifteen cartloads, a distance of some 35 miles. Following the assembly of the works, a local painter was employed the following year for 'inriching' them. This tremendous outlay of energy and money, the shipping of materials back and forth (for the alabaster would have come from the East Midlands to begin with), tells us about the growing importance of London as a centre for the kind of high-quality work that wealthy patrons wanted. In death, as in life, the very materials and skill that went into the making of the image had to conform to the most fashionable and luxurious.

20 Nicholas Johnson, sculptor
Tomb of the 4th Earl of Rutland (d.1588)
Bottesford Church, Leicestershire

The public and private lives of men and women

IF WE seek to know how portraits were displayed and understood in the great houses of Tudor England, then we need to bear in mind the wider social and visual context of their display. In 1538, the wealthy London merchant, Sir Thomas Kytson, paid for a spectacular oriel window to be made over the inner gateway to his country house at Hengrave in Suffolk. His huge wealth of profits in trade through the Merchant Adventurers Company had enabled him to lend money to Henry VIII, but he carefully acknowledged the sense that all wealth, indeed all privilege was held under the King, for under the oriel he had his own coat of arms placed beneath that of the Crown. At the time of completion of this house, therefore, there was already in place an heraldic acknowledgement of the social order in which Kytson had bought his place. In 1573, his posthumous son, also called Thomas, went to London with his wife Elizabeth Cornwallis and there they were painted by George Gower, later Serjeant Painter to Elizabeth I; the pair of portraits, now in the Tate Gallery's collection, were among a group of five works for which the younger Sir Thomas paid Gower £6 5s. 0d. (£6.25). In later years, other portraits by Gower seem to have been commissioned by the Kytson family, including the Kytson women at the time of their marriage into some of the country's leading families; Lady Kytson's sister Mary, who married the Earl of Bath and the Kytsons' daughter Margaret who married, in 1581, Sir Charles Cavendish, son of Bess of Hardwick. Hengrave Hall, first built and ornamented to mark the Kytson fortunes in the early Tudor period, was thus filled with portraits testifying to their later social success.

This acknowledgement of social standing reached, web-like, from house to house. Margaret Kytson, Lady Cavendish, died in 1582, the year after her marriage, but she would nevertheless also have been painted for Bess herself, to hang among her collection of portraits in the new Hardwick Hall, under construction during the 1590s. We know from the inventory taken at Bess's death in 1608 that 37 family and royal portraits hung in the Long Gallery; later her son William was to supplement this by having the artist Rowland Lockey copy further portraits of royal and other people. The hang of pictures in the Gallery at Hardwick today is largely the creation of the early nineteenth century; it seems that in 1608 the pictures were not hung on tapestries but largely on the window wall and in the great embrasures there. Bess's gallery is however a rare survival among the great long galleries of Tudor England, though it was by no means

21 Hengrave Hall, Suffolk. The oriel window, with the royal arms over those of the owner, commissioned by Sir Thomas Kytson in 1538

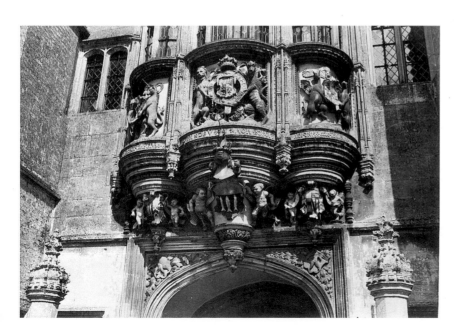

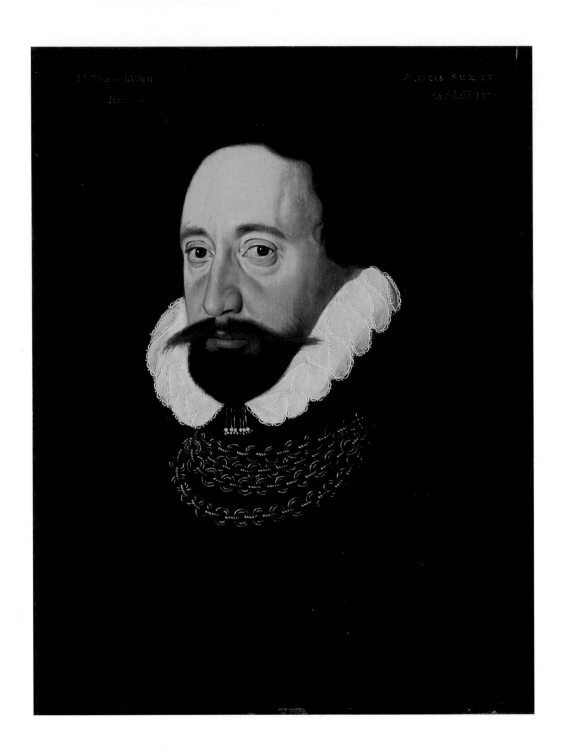

22 George Gower
Sir Thomas Kytson 1573
Oil on panel 52.7 x 40 cm
Tate Gallery, London

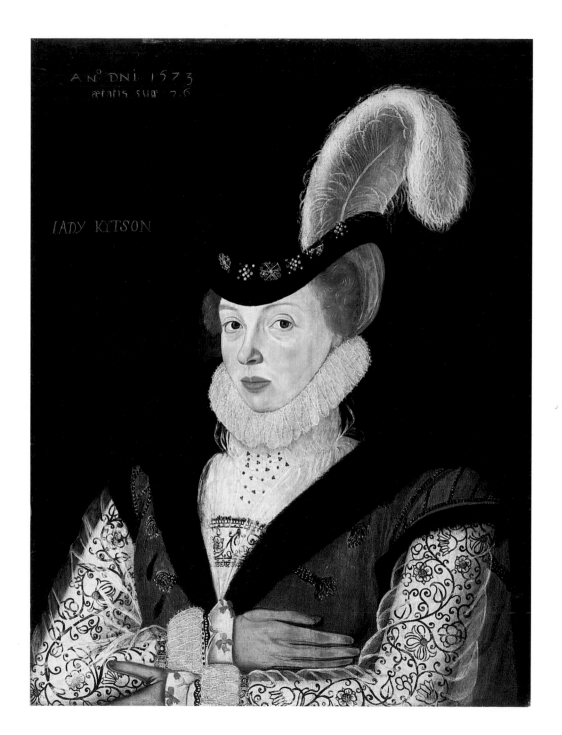

AN° DNI 1573
ætatis suæ 26

LADY KYTSON

23 George Gower
Elizabeth Cornwallis,
Lady Kytson 1573
Oil on panel 67.9 x 52.1 cm
Tate Gallery, London

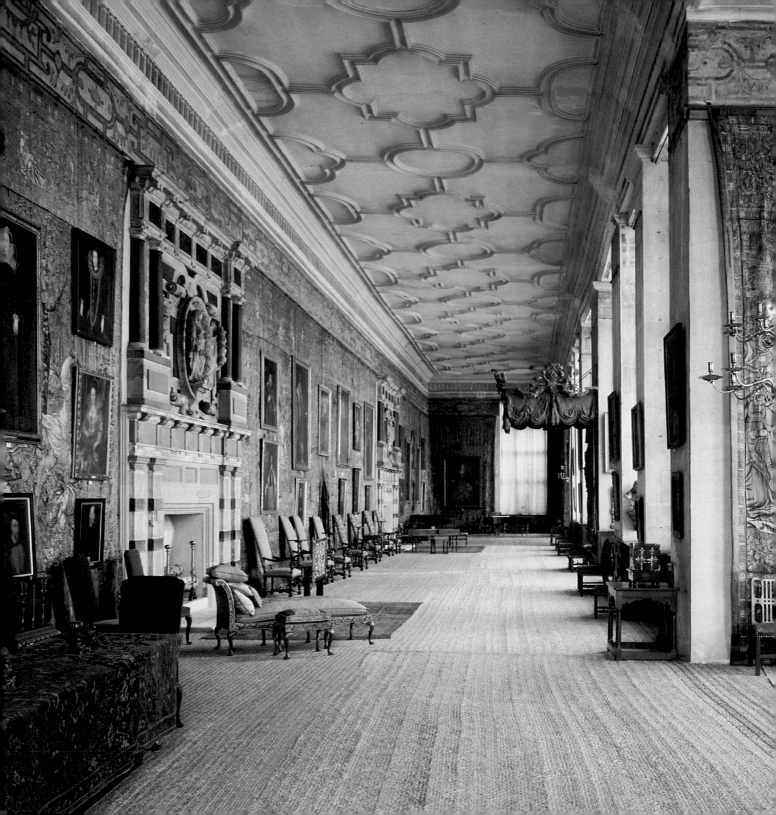

the most populated with pictures; the gallery of the Earl of Leicester and that of Lord Lumley, whose inventory of his collection at Lumley Castle has survived, had considerably more. Whilst Bess scattered smaller portraits, some religious pictures and one or two mythological subjects among the more private rooms of the house, the Long Gallery spoke loudly of family power and connections through its portraits.

Many of the full-length portraits that had become so popular by the late Elizabethan period were painted for large spaces such as these; hung together, portraits of the same family would echo each other by family likeness and complementary coats of arms. The aim therefore was quite limited in portrait painting but there were nevertheless great differences in the range of content an artist could utilise, particularly between the sexes. If the first and dominant message of any portrait on view was the public role of the sitter, then male portraits tell us more. Men were far more likely to have done something publicly notable in their lives, since they could be politicians, soldiers or scholars, roles that most women were not permitted to enjoy.

Two famous Elizabethan courtiers show something of the range established for male sitters by the late sixteenth century. *Robert Dudley, Earl of Leicester* dates from the1560s so we know that, like the Eworth portrait with which this book began, information has been added later to underline his achievements; the coats of arms ringed by the different orders he was granted and the inscription to the left recording his generalship of Queen Elizabeth's army in the Netherlands in the 1580s. An awareness by the artist of European conven-

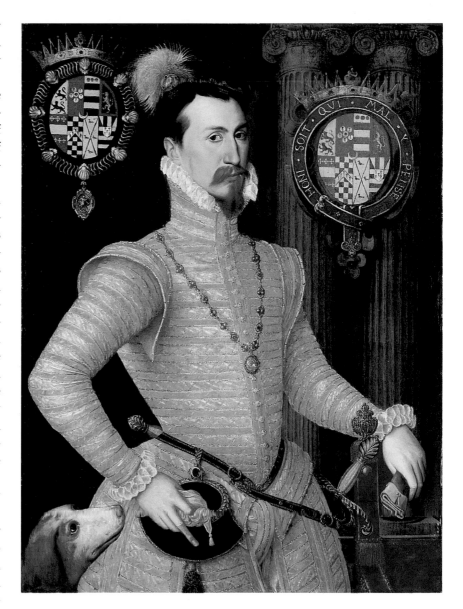

24 *Left* Hardwick Hall, Derbyshire. The Long Gallery. When this room was created for Bess of Hardwick in the 1590s, paintings were displayed mainly in the window bays

25 Anglo-Netherlandish School
Robert Dudley, 1st Earl of Leicester
*c.*1564-6
Oil on panel 110 x 80 cm
Private Collection

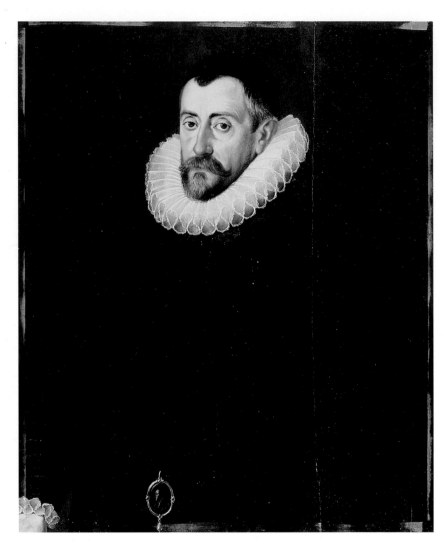

26 Attributed to John de Critz the Elder
*Sir Francis Walsingham c.*1587
Oil on panel 76.2 x 63.5 cm
National Portrait Gallery, London

tions of portraiture is shown by the familiar use of the dog who, in gazing towards Leicester, prompts a similar deference from the viewer of the portrait. *Sir Francis Walsingham,* Elizabeth's Secretary of State, arranged for the Flemish artist John de Critz to travel abroad during the 1580s, possibly as part of the network of spies that Walsingham employed to protect the Queen against foreign enemies. The version shown here of de Critz's portrait of Walsingham is just one of several extant, demonstrating the way in which images of powerful figures at Court were replicated for country house collections.

On the opposite side of allegiance to the status quo, some men also identified themselves as opposing the government of the day, or even as leaders of rebellions. The Catholic Howard family played a series of dangerous games in opposition to the Tudor dynasty throughout the century. The Earl of Surrey, son of the third Duke of Norfolk, had been executed for high treason in the last days of Henry VIII's reign; part of the indictment against him had been his temerity in assuming quarterings of the royal arms in the decoration of his house. When Hans Eworth fell from royal favour for some years after the death of Mary I, he sought the patronage of leading Catholic families and so in 1563 painted Surrey's son, Thomas Howard, by this time restored to full honours as the fourth Duke of Norfolk. He is portrayed before a cloth of honour with the family arms emblazoned upon it. The restoration of favour was short-lived, for the Duke's part in the Northern rebellion of 1570-71 and his ambition to marry Mary, Queen of Scots, cost him his life in 1572.

However it is not only in reference to po-

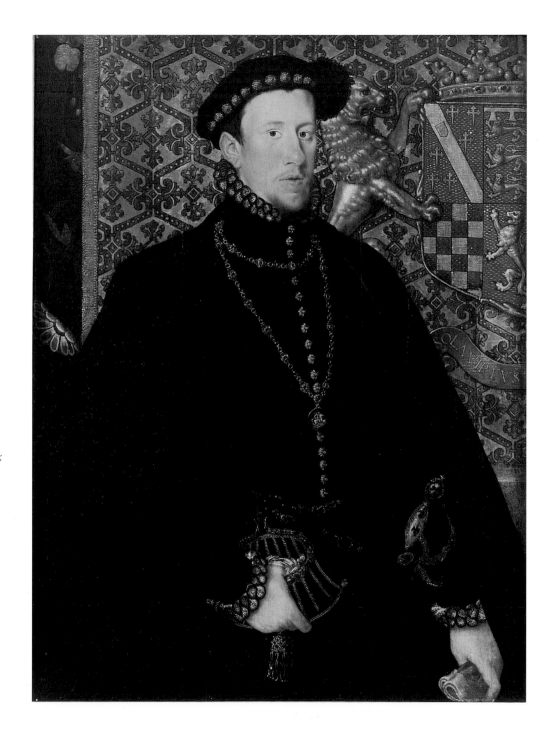

27 Hans Eworth
Thomas Howard, 4th Duke of Norfolk
1563
Oil on panel 108.6 x 81.3 cm
Private Collection

litical or military deeds that male portraits present us with an assertiveness denied to female sitters. In the collections of full-length Jacobean portraits now at Ranger's House, Greenwich, is the so-called 'Suffolk Set' of related female figures, all standing on expensive eastern carpets and placed between stiff, folded-back curtains, with one hand hanging loosely, the other placed on a chair to one side or, in one case, a table. They now hang in the company of a portrait dated 1613 of Richard Sackville, third Earl of Dorset. The picture is so close in format and style to the 'Suffolk Set' that it has been attributed to the same artist, William Larkin. We are drawn, as in the female portraits, to the surface patterns on his garments, probably those worn at the wedding of James I's daughter Elizabeth in the same year, and the open curtain that frames him. Yet, compared with the reticence of the women, his stance, with hands poised on hip and sword, suggests an incipient action which they are denied.

The range of guises possible for men means that they are often easier to identify; there are probably more unknown women than men among surviving portraits from this time. The lack of information about female sitters is found as early as Holbein, who usually provides more data in background inscriptions, or writing in scrolls held in the hand, in male than in female portraits. The identity of the *Lady with a Squirrel and a Starling*, of about 1526-8, now in the National Gallery, is tantalisingly unknown to us. It is tempting to wonder whether the pet squirrel and starling are allusions to heraldry or perhaps puns on the sitter's name, for Holbein would have been aware of the complex games some Italian art-

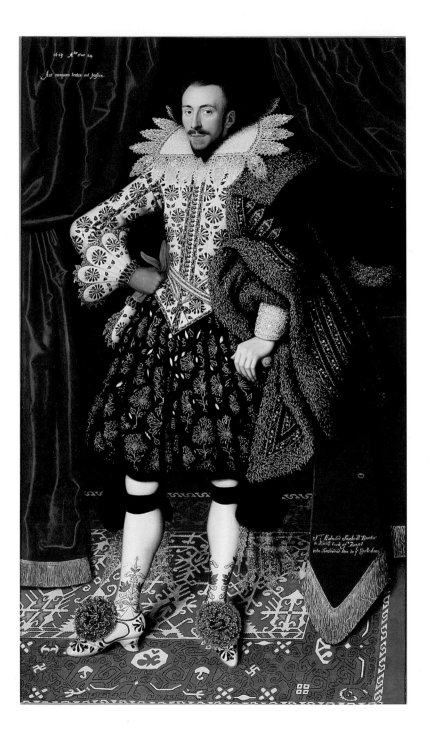

28 *Left* William Larkin
Richard Sackville, 3rd Earl of Dorset
*c.*1613
Oil on canvas 206.4 x 122.3 cm
English Heritage (Ranger's House,
The Suffolk Collection)

29 Hans Holbein the Younger
*A Lady with a Squirrel and a
Starling* 1526-8
Oil on panel 56 x 38.8 cm
National Gallery, London

30 Cornelius Johnson
Susanna Temple 1620
Oil on panel 67.9 x 51.8 cm
Tate Gallery, London

ists played with their sitters' names in this way. Since she wears neither jewels nor outdoor costume of the sort she would have had to wear at Court, this must be a very private work, whose identity was known to only a few. Nearly a century later, a similarly delicate and reticent image, painted by Cornelius Johnson, is known to be of Susanna Temple, partly because it was engraved and named later in the seventeenth century and partly through the martlet in her earring which is the crest of her family.

It is interesting that even when portraits are expressed in allegorical form, where the figure takes on a form of disguise to accentuate a particular quality or virtue, this convention is still invariably used to underline male activity and achievement but female subservience to the family. The male in heroic mould could be portrayed partly naked even when celebrating his public achievements, because this could be conceived as idealising the human form in action. Any hint of nakedness would have been improper for high-born women, however, in anything but the most private pictures.

Two allegorical portraits of male subjects appear to be a visual means of coming to terms with the frustrations of a life of action curtailed and reined in by the actions of government. Hans Eworth's portrait of *Sir John Luttrell* dates from 1550. In 1548 Luttrell had been the commander of an English garrison on the beleaguered island of Inchcolm in the Firth of Forth at a time when the French were supporting their old ally, Scotland, in making trouble for the English after the latter had invaded and won the battle of Pinkie. The ship which rescued Luttrell nearly foundered; reference to this incident is made at the right of the por-

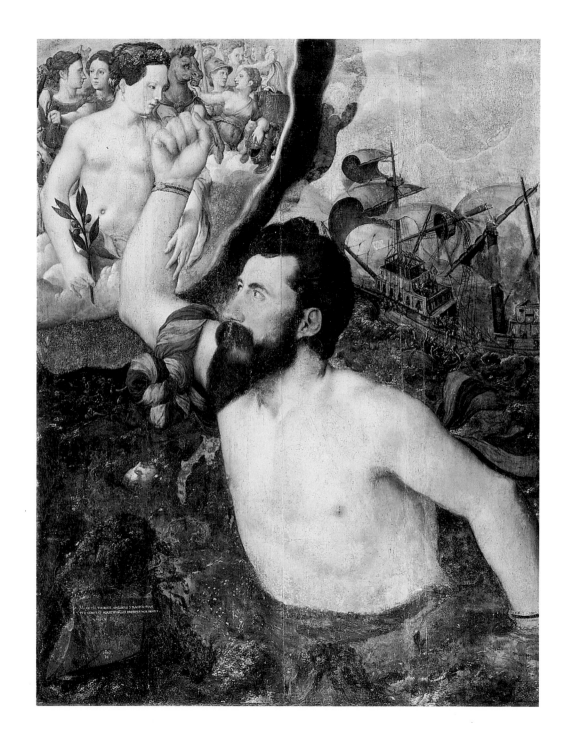

31 Hans Eworth
Sir John Luttrell 1550
Oil on panel 109.3 x 83.9cm
Courtauld Institute Galleries,
London (Lee Bequest)

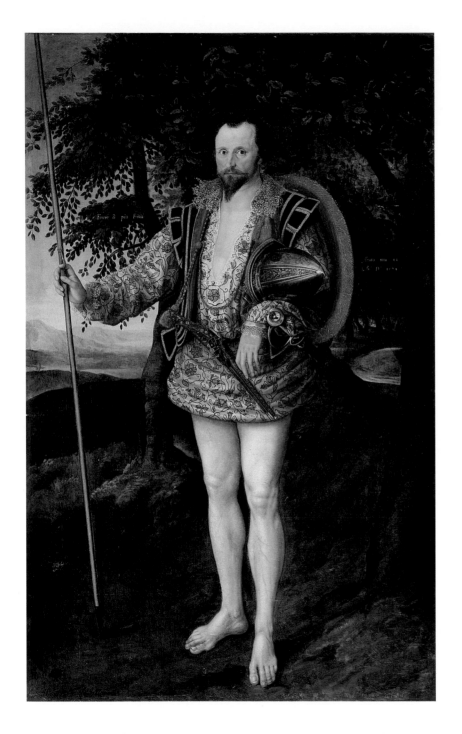

trait. At the time Eworth painted him, Luttrell had to accept the making of peace with France and so, disarmed and rising from the sea, he is embraced on the left by the figure of peace, appearing to him as if in a vision. Luttrell died the following year while preparing for an ambitious expedition to Mexico.

A different kind of play on military enterprise is seen in the portrait of *Captain Thomas Lee*, by Marcus Gheeraerts, painted in 1594. Lee, nephew of Sir Henry Lee, who held the post of Champion to Elizabeth I, spent most of his military life in Ireland and he is shown here dressed as the 'Miles Hibernicus', or Irish Knight, from a contemporary costume book. It is likely that he wore a version of this costume at a court masque where he could show off his valour; the Latin motto hanging in the tree beside him is a citation from Livy indicating that he is always ready to be brave and ready to suffer for it. Suffer he eventually did, for he was executed in 1601 for his part in the Essex Rebellion. His naked legs are usually said to be his means of traversing the peat bogs of Ireland, and doubtless a specific literary source can be quoted to support this. What they also tell us however is something about the way in which, for some centuries before our own, the male leg was made into a fetish, a sign of action and of skill at horsemanship, in much the same way that the female leg has been fetishised as a sexual signal in the twentieth century.

By contrast, the portrait of *Lady Elizabeth Pope* by Robert Peake is an image of a woman defined by the way her image would be read and understood in terms of the men who possessed her, husband and father. A recent analysis of this image has stressed the tension be-

32 *Left* Marcus Gheeraerts the Younger
Captain Thomas Lee 1594
Oil on canvas 230.5 x 150.8 cm
Tate Gallery, London

33 Attributed to Robert Peake
*Lady Elizabeth Pope c.*1615
Oil on panel 77.5 x 61 cm
Tate Gallery, London

tween on the one hand the conventions of Elizabethan portraiture, both in the flatness of presentation and the way she encloses her own body with her arms, and on the other the voluptuousness of the arrangement of her loose hair and the potentially exposed body. The picture was probably commissioned by her husband, Sir William Pope, at the time of their marriage in 1615, but the sitter is replete with the symbols of the man by whom she has been given away. It has been suggested that the ostrich feathers embroidered in pearls on her robe and hat are probably a reference to contemporary allegories of America; her father, Sir Thomas Watson, was a chief player in the early colonisation of and trade with the New World through his involvement with the Virginia Company.

Only in extraordinary circumstances could women appear in their portraits as the initiators of action. Retrospectively, the full-length image of Frances Sidney, Countess of Sussex, testifies to her activity as the foundress of Sidney Sussex College, for which purpose she left £5000 in her will of 1589. Shortly after the college came into being, in 1594, this great portrait of her, painted probably twenty years earlier, was in all likelihood given to the college by her family to honour her patronage. A more personal image, yet one which shows a woman triumphing through perseverance against the political system, is demonstrated by the two portraits painted by Eworth of Mary Neville, Lady Dacre. The first, of 1555, shows her seated before a tapestry on which hangs a small Holbein portrait of her first husband, Thomas Fiennes, Lord Dacre, who had been executed in 1541 (unjustly as many believed) for the murder of a gamekeeper. Lady

Dacre became the 'good' widow of her late husband, not through any chaste loyalty to him, for she married again twice, but in terms of keeping faith with his memory through her attempts to restore the family's honour for the sake of their son and heir, Gregory. Lands and titles were indeed restored to the family at Elizabeth I's accession, and in 1559 Lady Dacre commissioned Eworth to paint her once more, this time in a double portrait with her son, the new tenth Lord Dacre, as a record of this moment of justice and restitution. Knowing this history, we are made aware of an unusual balance of power between the sexes here in this image of mother and son.

Only a few portraits of family groups survive from this period. The most significant loss is undoubtedly the original Holbein of *Sir Thomas More and his family*, painted about 1527 and recorded in the famous picture collections of both the Earl of Arundel and Lord Lumley in the early seventeenth century, before it passed out of England and was destroyed by fire in the eighteenth century. Among copies and derivations is the miniature, in its walnut cabinet with double doors, probably painted for Sir Thomas's grandson by Rowland Lockey about 1590-95. This repeats the basic format and many of the figures of the lost Holbein, known to us in the artist's preliminary drawing for the work; but Lockey has added family heraldry to the back of the tester on the left and, to the right, a group of late sixteenth-century descendants of More in front of a view on to a Tudor garden and a distant prospect of London. The original Holbein painting was for its time an astonishingly informal composition of figures, reflecting, through the presence of books and the sense of dialogue be-

tween the subjects, the humanist views and learning of More's household at Chelsea, extended here even to the women of the family.

The Family Group of Lord Cobham of 1567 is far more typical of the period and could not be more different. Here, reminding us of the formal arrangements of figures on monuments to the dead, Lord Cobham and his wife stand behind a table at which sit their six children, boys on the left before their father, girls on the right before their mother. The woman on the left is believed to be Lady Cobham's sister. Despite the eating of dessert which seems to be going on, by comparison with the More group and its informal cross-currents of conversation we here feel pulled back towards perceiving a message that is essentially heraldic in character. It is as if all these people and objects have been laid out to convey genealogical information rather than to record a point in time; none of the sitters, we note, look at each other. The sense of unreality is reinforced by the setting. This is clearly not a domestic space as such, for the figures are flanked by the bases of a great classical column on one side and a plinth on the other, as if this were the frontispiece to a book.

This work does however tell us a great deal about aristocratic families of the period. All six children were born within the first seven years of the Cobhams' marriage. In this, they are typical of their class since the aristocracy and gentry generally produced more children than the less-privileged classes; they tended to marry at a younger age, being important bearers of property and title, and women therefore had a longer reproductive span. However, death was no respecter of class and only some of the Cobham children would survive; in fact

34 British School
Frances Sidney, Countess of Sussex 1570–5
Oil on panel 193 x 111 cm
Sidney Sussex College, Cambridge

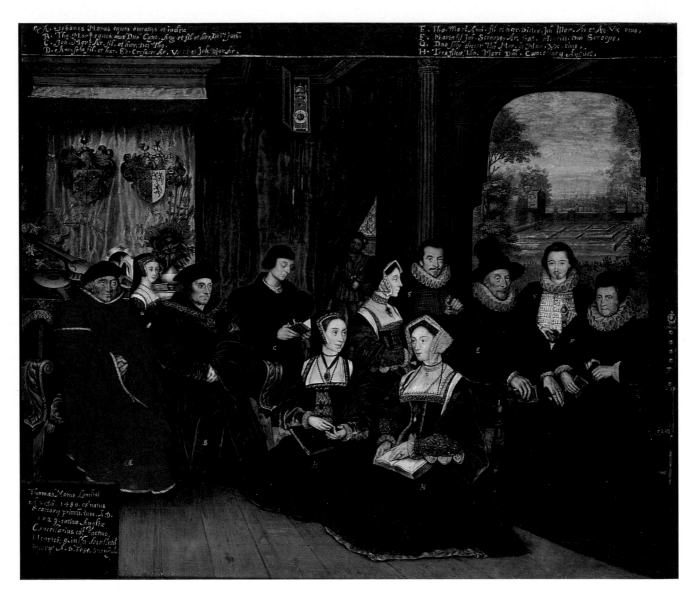

36 Rowland Lockey
The More Family, Household and Descendants 1593-4
Vellum stuck on card 24.6 x 29.4 cm
Victoria and Albert Museum, London

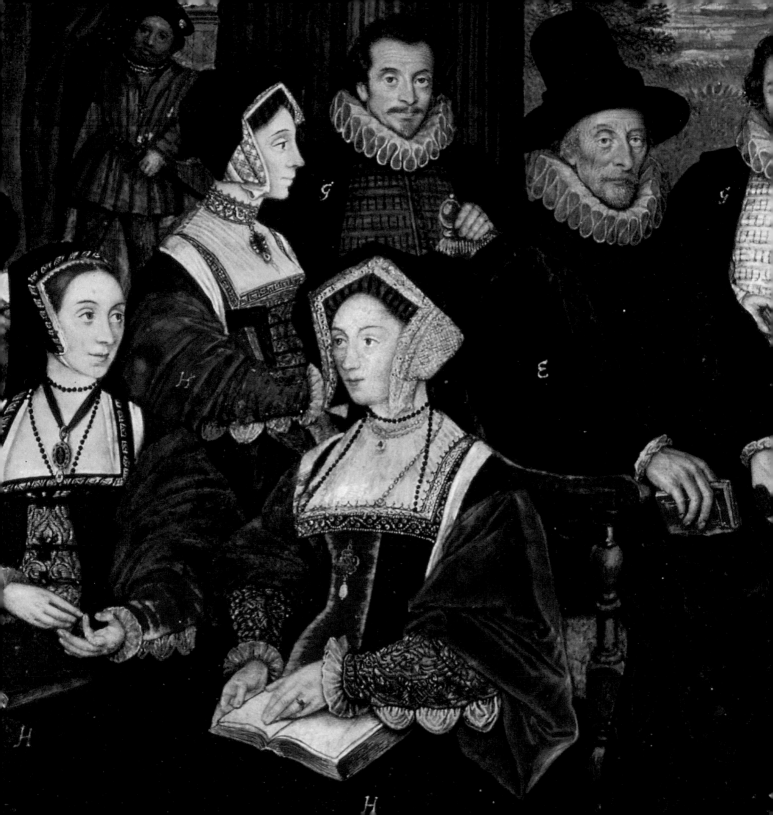

35 Hans Eworth
Lady Mary Neville and her Son Gregory Fiennes, 10th Baron Dacre 1559
Oil on panel 50.2 x 71.4 cm
Private Collection

37 British School
William Brooke, 10th Lord Cobham and his Family 1567
Oil on panel 91.7 x 120 cm
The Marquess of Bath, Longleat House, Warminster, Wiltshire

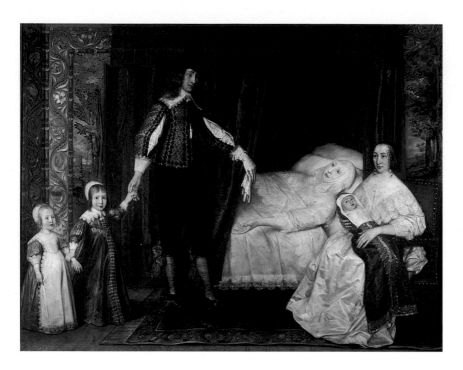

38 David des Granges
The Saltonstall Family c.1636-7
Oil on canvas 214 x 276.2 cm
Tate Gallery, London

it was the youngest of the three boys at the left who was to outlive his father and succeed to the title. Whilst there is considerable evidence that people were affected by the death of their children, it is interesting that we do not find the overt sentimentality about children that appears in portraits and monuments of later periods.

In fact a strong sense of emotion, drawing on loss, stems from the Tate Gallery's *Saltonstall Family* by David Des Granges of about 1636-7. Here we are in the presence of the sort of family imagery more familiar from church monuments, since both Sir Richard's dead and living wives are portrayed. His second wife sits in a chair with their newly-born child, but it is to the earlier, dead wife that Saltonstall appears to lead the two children of the first marriage. It has sometimes been suggested that they are shown at the age they were at the time of their mother's death. The painting is thus broadly about family ties and affections., but it is centred on the male figure, for the work chiefly records the grief and the joy that have held his life together. The work may also draw on contemporary prints of domestic life, particularly those by the French artist Abraham de Bosse, for this was a time when scenes of birth and death in fashionable contemporary settings circulated widely and were used as the compositional setting for commentaries on the human condition.

The great size of the *Saltonstall Family* suggests a public locality within a house. Other sixteenth-century images were more private in character and fulfilled the role of a personal exchange between friends or relatives. In the early part of the century, Holbein and the Flemish artist Quentin Metsys were engaged

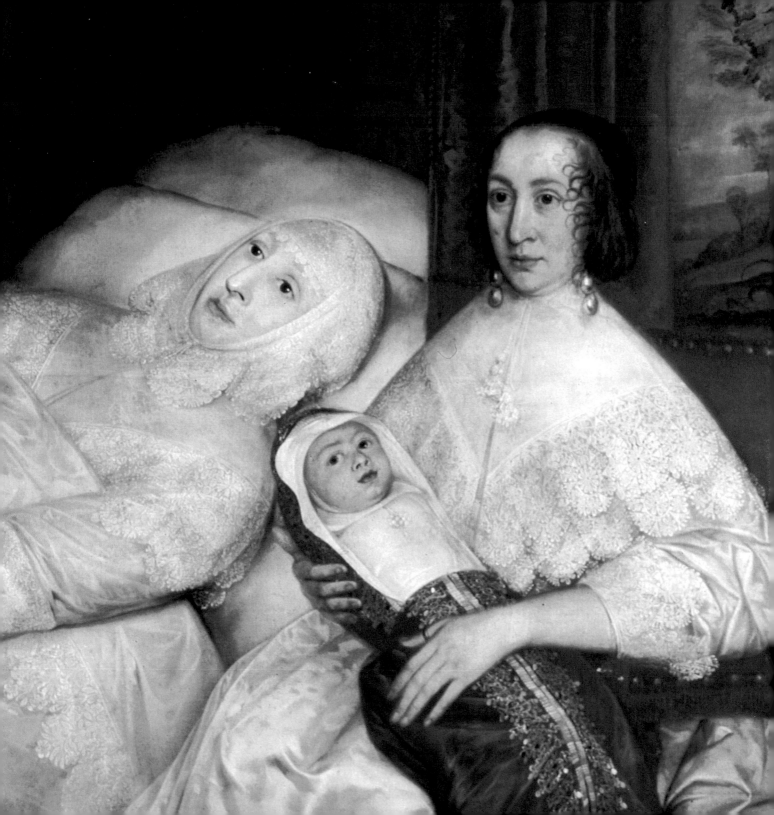

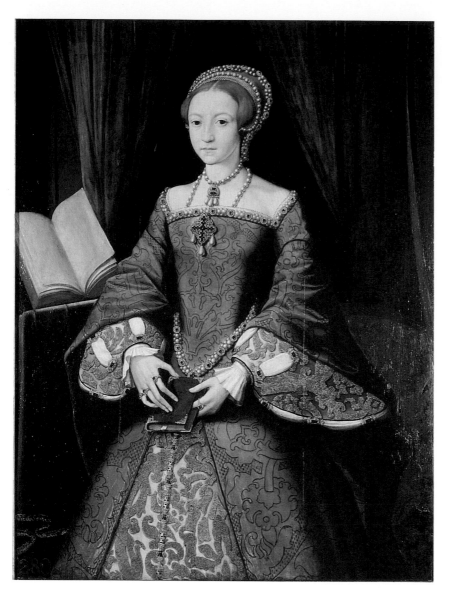

39 ?Flemish School
*Elizabeth I when Princess c.*1546
Oil on panel 108.5 x 81.8 cm
The Royal Collection. Her Majesty The Queen

in painting portraits of Erasmus, Sir Thomas More and their circle as part of a gift exchange of likenesses between scholars. These were images kept in private studies. Portraits could be an aid to memory in the absence of the friend or loved one. In May, 1547, Princess Elizabeth sent her picture to her brother, the new king, Edward VI, just four months after they were separated at the time of their father's death. This could have been the image of her at the age of thirteen, now in the Royal Collection. In the accompanying letter, Elizabeth writes: 'And further I shal most humbly besche your Majestie that when you shal loke on my pictur you wil witsafe it to thinke that as you have but the outwarde shadow of the body afore you, so my inwarde minde wischeth that the body it selfe were oftener in your presence'. This making of the absent present and the recall of personal affections and ties of blood is most fully shown to us in the sixteenth-century fashion for miniature painting.

The social milieu of the art of miniature painting is one that began, and essentially remained, an art centred on the Court both in Tudor and early Stuart times. The period of the miniature's chief importance for the history of English painting begins when Henry VIII employed the Flemish family of Horenbout, from Ghent, to paint miniatures of himself and Catherine of Aragon in the mid-1520s, and ends with the work of Isaac Oliver for James I and his family a century later. This is not to say that only people at Court were represented by the great miniaturists. Certainly Nicholas Hilliard, the greatest exponent, extended his work into the commercial classes of London. Some of his portrayals, like that of

the wealthy, Devon-born merchant Leonard Darr, who married into one of the great City of London families, show a frankness and simplicity true to the careful, naturalistic origins of the miniature. But it was in work for Court patrons that the miniature became increasingly emblematic, developing the private world of personal allusion and an image of the private self in a manner quite different from that of portraits in public places. This is what marks out the miniatures of the Elizabethan and Jacobean age as special; by the second half of the seventeenth century, miniatures settled into being more like reduced versions of full-size portraits, and their distinctiveness as an art form was transformed.

Contemporary accounts of the viewing of miniatures underline both their sense of privacy and the privilege of seeing something of personal value to the owner. Sir James Melville, ambassador from Mary, Queen of Scots, has left us a description of the moment when, in 1564, he was taken by Queen Elizabeth into her innermost private room to be shown a miniature of the Earl of Leicester. The Queen kept her miniatures in a small cabinet, wrapped separately in paper. Melville records a considerable coyness on the part of the Queen as she afforded him a view. Similarly, when Sir Henry Unton, English ambassador to the French court, discussed the royal mistress with the French king in the privacy of Henri IV's apartments, he recalls how he told the king 'that if, without Offence I might speake it, that I had the Picture of a farr more excellent Mistress, and yet did her Picture come farr short of the Perfection of Beauty. As you love me (sayd he) shew it me, if you have it about you. I made some Difficulties;

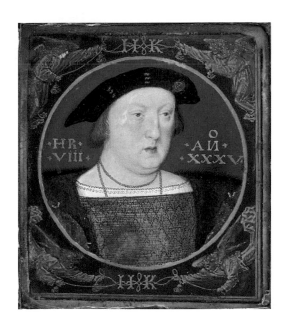

40 Lucas Horenbout
*Henry VIII c.*1525–7
Vellum stuck on card 5.5 x 4.8 cm
Fitzwilliam Museum, Cambridge

40b Nicholas Hilliard
Self-Portrait 1577
Vellum stuck on card, diameter 4.1 cm
Victoria and Albert Museum, London

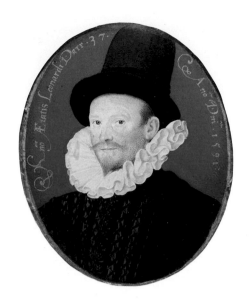

41 Nicholas Hilliard
Leonard Darr 1591
Watercolour on vellum stuck on
playing card 7 x 5.7 cm
Private Collection

yett, uppon his Importunity, offred it unto his Viewe verie seacretly, houlding it still in my Hande'.

Many surviving miniatures still remain in their original casings and these emphasise their jewel-like quality, just as Hilliard's technique of floating the raised gold and the white of ruffs and embroideries over the surface echoed the tactile quality of looking at a faceted, shimmering surface. In one way, it is helpful to think of these miniatures as the reverse of the public lives of these people who were constantly on display. However, it has also been argued that we should not underestimate the opportunity people took to let even these private miniatures mask their true selves. If Renaissance courtiers learned anything from the books of advice on education and behaviour that came to shape their lives, it was the quality of dissembling and pretending which was a vital part of keeping one's guard in this dangerous environment; Queen Elizabeth's coyness and Unton's reluctance are perhaps part of a game whereby the truly private self is never fully revealed, because politics forbade it. Miniatures could therefore be signs of wish-fulfilment and of ambitious feelings. Many of the later miniatures of men at the courts of Elizabeth and James I show them in modern dress, adapted however to signal their image of themselves as chivalric knight. In the small picture of Lord Herbert of Cherbury by Isaac Oliver of about 1610-14, the sitter ponders the choice between a life of military action and the world of books and philosophy. The size of this miniature, which could not be worn about the person, takes us into a different world of private display. Now such objects were displayed together in collectors' small rooms, or cabinets, where the virtuosity of art itself and what it could achieve is more significant than the personal message for a particular sitter or the work's recipient. They thus reflect the taste of the collector who owns such things. In a sense, therefore, in the highest ranks of society, even these small and ostensibly personal objects came eventually to offer a public message about the values their owners shared with their own social class.

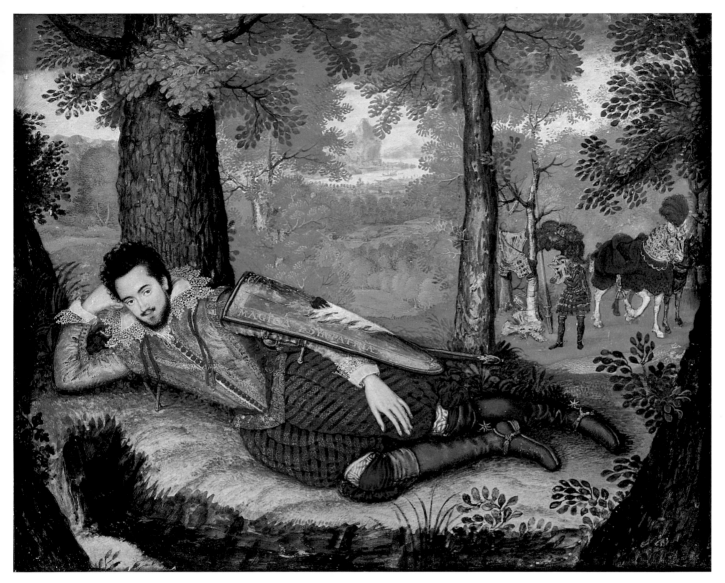

42 Isaac Oliver
Edward Herbert, 1st Baron Herbert of Cherbury 1613-14
Vellum on card 18.1 x 22.7 cm
The Rt Hon Earl of Powis

Imagining the nation

AT THE CLOSE of the twentieth century, commentators on the state of the world talk about the end of the concept of the nation state. The European origin of this idea goes back to a time between the fifteenth and seventeenth centuries when countries, Protestant and Catholic, began to fight amongst themselves for the opportunity to exploit the resources of the wider world overseas. If we turn to Tudor England, no longer directly involved in European land wars after the fall of Calais in 1558, where did people's sense of national identity lie? Tudor governments were certainly increasingly interventionist in people's everyday lives in many ways, such as through the enforcement of new religious practices, through measures like the Poor Laws which sought to mitigate the worst of the social effects of inflation and through the need to protect the country's borders by ring-fencing them with fortifications. But did people have a sense of identity larger than their own immediate locality and self-interest? Did visual imagery play a part in inculcating a sense of what 'England' meant?

Having an image of one's country in one's head will first of all involve confidence about ascribing to it a visual shape that can be remembered. Two significant factors influenced the emergence of some of the first distinctive national and county maps at this time. One was the need for defence itself; a clear record of the country was an offshoot of the careful plotting of the contours of the coastline in a way never undertaken in such detail before. The second factor was the result of the great upheavals of land ownership following the Dissolution; new owners wanted their lands plotted, measured, surveyed. New techniques and

instruments for just this purpose came into being. But maps were more than practical tools. The great atlas of England and Wales by Christopher Saxton, first produced in 1579, offered a view not simply of the geographical shape of the country but of its important sites - towns, villages, houses, royal forests - for all of which Saxton had to invent recognisable symbols. These maps were emblazoned with national and local heraldry framed in elaborate cartouches of strapwork, the commanding form of ornament that was beginning to serve as decoration for frontispieces, jewellery, all aspects of the exterior and interior decoration of buildings. By the second half of the sixteenth century, maps are sometimes recorded in inventories as hanging alongside portraits in long galleries. A further sign of the decorative value of maps was the establishment of the Sheldon tapestry works at two sites, in Warwickshire and Worcestershire, where county maps were turned into huge wall-hangings.

Also in long galleries, owners of great houses sometimes had sets of representations of the English monarchs of the past, painted bust-length. These could be ordered *en bloc* from a painter's workshop and were expected to be only approximate likenesses of past monarchs, not that in many cases these were known anyway since even possible sources such as coin and tomb effigies were stylised. Portraits of past sovereigns were usually pressed close to each other in serried rows, as we see today in an early seventeenth-century set in the Brown Gallery at Knole, in Kent, home at this time of the Richard Sackville whose full-length portrait we looked at earlier. Such sets are a ready-made history, an appropriation of the

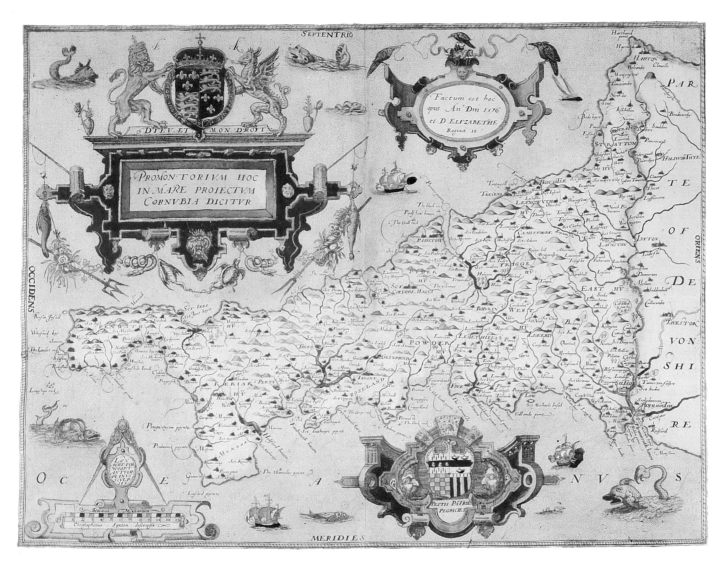

43 Map of Cornwall from Christopher Saxton's *Atlas of the Counties of England and Wales*, 1579. British Library

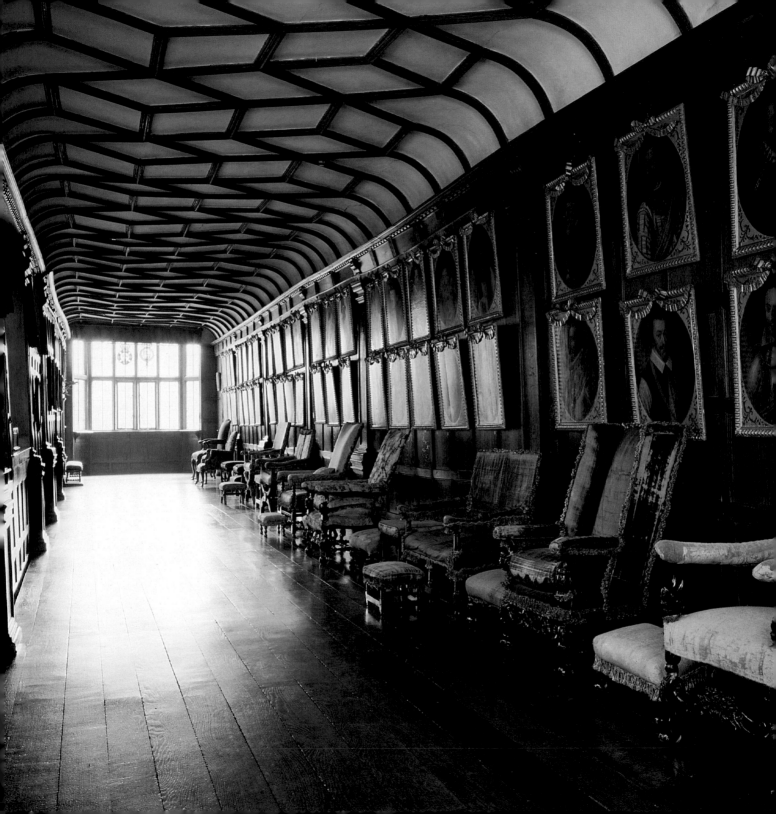

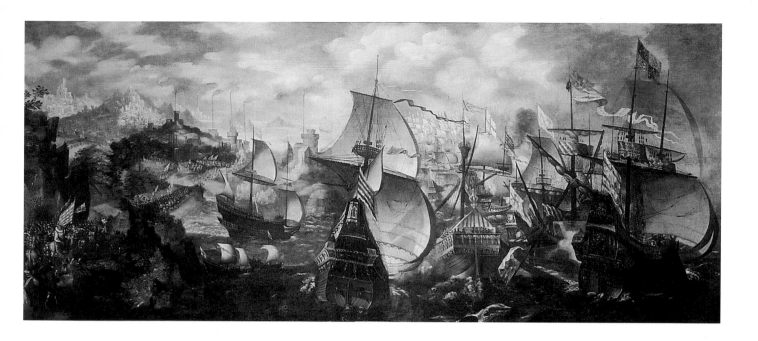

44 *Left* Brown Gallery, Knole, Kent. Remodelled by the 1st Earl of Dorset in the early seventeenth century and lined with portraits of historical figures painted in the same period

45 *Above* British School *The Spanish Armada* c.1590 Oil on canvas 121.3 x 284.5 cm The Worshipful Society of Apothecaries of London

past to sit alongside family and current royal portraits. These might be accompanied by historical pictures representing great recent events in England's naval or military history. There are references in inventories, and indeed versions of them survive today, to paintings of the Battle of Pavia of 1525; as this was the battle at which Francis I was captured by the Emperor, the image served as a vicarious way of celebrating the downfall England's arch-enemy, the French. A surviving canvas painting of the Spanish Armada, of about 1590, displays the subject rather like a map, as if from a bird's eye view. It encapsulates several parts of the action all at once: the Queen's address to the troops, an impression of ships engaged in battle which conflates several episodes of the story and a stormy sea merging imperceptibly into a coastline lit by beacons. The tale of

the Armada's defeat has already here been generalised and mythologised as part of England's national history.

Along with maps went, however, an interest in quite exact topographical representation when demanded. It has been suggested that the famous drawings, now in the Ashmolean Museum, of five of the Tudor royal palaces made by Anthonis van den Wyngaerde in the 1550s were prompted by the enthusiasm of Philip of Spain, at the time of his marriage to Mary I, for the depiction of towns and cities in the Spanish dominions in the royal palaces of Madrid. Examples of the decoration of ducal and papal courts with prospects such as these can still be seen today in the courtyard of the Palazzo Vecchio in Florence and the galleries of the Vatican. The Tate Gallery's small painting by Alexander Keirincx of *A distant view of*

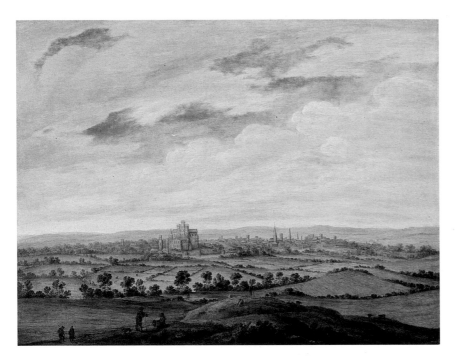

46 Alexander Keirincx
Distant View of York 1639
Oil on wood 52.9 x 68.7 cm
Tate Gallery, London

York of 1639 has the brand of Charles I on the back, indicating that it was probably one of ten views of English cities he commissioned in that year, so this is a modest but significant addition to an important type of picture, recording places where royal authority ran.

The most obvious embodiment of a national image however is the iconography of its figurehead. Certainly the Tudor and early Stuart monarchs exploited a sense of their position as embodying the country both physically and spiritually. Elizabeth I's speeches at moments of crisis, most famously in the Tilbury speech before the Armada, unite an image of the nation in words with her bodily presence in an emphatic way. But since monarchs used imagery in quite different ways, the range of forms taken by their images are an important

barometer of changing and evolving ideas of what the country itself represented.

How widespread and indeed recognised was the image of the sovereign? Perhaps the most widespread image was that on the coinage; Tudor monarchs broke early with the convention of rather generalised full-face representations common in the medieval period and adopted the more fashionable, more powerful classical profile. But the power of the coin image took time to develop; Henry VIII used his father's image on some coins for some seventeen years into his reign. Images of Tudor sovereigns in prints also circulated widely and created a mythology about them which sometimes served as propaganda for the common identity of church and state. Historians have explored the complexities of much of this imagery, stressing the biblical and classical prototypes that sovereigns embodied. However, quite how widely these images would have been recognised, dependent as they are on intricate programmes of iconographic cross-reference, is hard to pin down. Certainly we can imagine how the printed image of Edward VI as the young Josiah, or Elizabeth as Deborah, could be reinforced by strong words from the pulpit on the occasion of threats to the reformed faith from within or without the state.

Across the country, however, fear and respect were inspired less by the personal royal image than by other signs of the royal presence, such as the royal arms, the badges and devices that the crown's officers wore as they went about their duties enforcing the law. Imagery, we must constantly remind ourselves, lay not only in the depiction of the physical body of monarchy but in other signs which stood in its place. These could also spark fear

47 Coinage of the five Tudor monarchs: (from top left) Henry VII, Henry VIII,
Edward VI, Mary I with Philip of Spain, Elizabeth I. British Museum

308

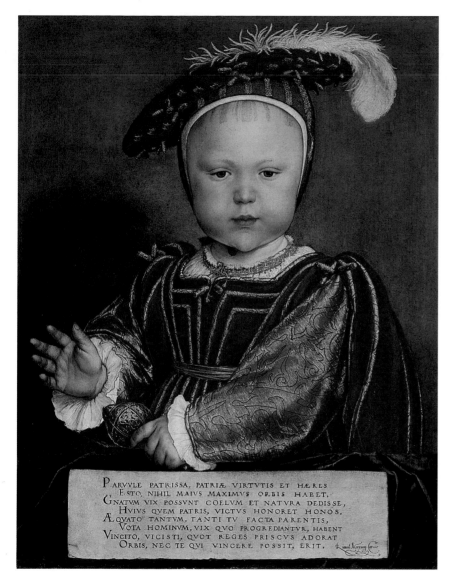

PARVVLE PATRISSA, PATRIÆ VIRTVTIS ET HÆRES
ESTO, NIHIL MAIVS MAXIMVS ORBIS HABET,
GNATVM VIX POSSVNT COELVM ET NATVRA DEDISSE,
HVIVS QVEM PATRIS, VICTVS HONORET HONOS.
ÆQVATO TANTVM, TANTI TV FACTA PARENTIS,
VOTA HOMINVM, VIX QVO PROGREDIANTVR, HABENT
VINCITO, VICISTI, QVOT REGES PRISCVS ADORAT
ORBIS, NEC TE QVI VINCERE POSSIT, ERIT.

48 *Left* Remigius van Leemput
*Henry VII, Elizabeth of York, Henry VIII
and Jane Seymour* (copy of the Whitehall
mural by Holbein) 1667
Oil on canvas 88.9 x 99.2 cm The Royal
Collection. Her Majesty The Queen

49 *Above* Hans Holbein the Younger
Edward, Prince of Wales c.1539
Oil on panel 56.8 x 44 cm
National Gallery of Art, Washington

and respect for royal power. At the Court itself, the visual allegorisation of the sovereign at its most arcane and erudite level could be more readily understood; in this setting it became the custom to discourse on the virtues of monarchy in the most flattering and deferential forms among an educated audience.

In the second half of his reign, Henry VIII used not only his huge physical presence in his portraits but also the most fashionable decorative imagery to underline his power. The surface application of classical ornament to clothes, buildings and temporary structures at Court was the first manifestation in England of the use of the Italian Renaissance as a way of projecting court culture as fashionable and glamorous. It served as the backdrop to the image of Henry VIII created by the painter Hans Holbein. In the lost wall-painting at Whitehall Palace, recorded in copies and a fragment of the cartoon, or full-size preparatory drawing, now in the National Portrait gallery, the King was shown with his recently-deceased third wife, Jane Seymour, and his parents, as testimony to the security of the Tudor dynasty. The classical screen behind them divides the work into three, just as in late medieval triptychs the subject-matter is divided between, most commonly, the Virgin and Child at the centre and attendant saints to each side. This covert use of familiarity with religious imagery would have made sense in this setting, for the myth of the power of the dynasty, represented by the great central plinth, is what these figures, like saints in an altarpiece, truly serve. There has been some dispute as to exactly which room in Whitehall had this painting on its walls but it was certainly a room of audience, with a throne

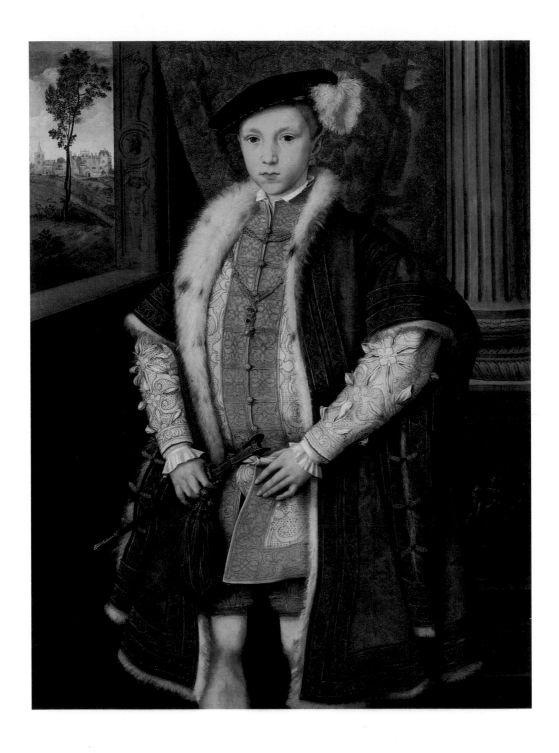

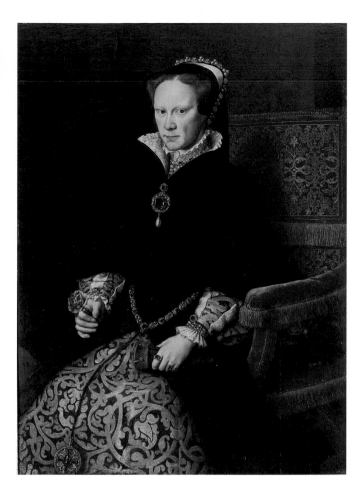

50 *Left* ?Flemish School
Edward VI *c.*1546
Oil on panel 107.2 x 82 cm
The Royal Collection. Her Majesty The Queen

51 *Above* Antonis Mor
Mary I 1554
Oil on panel 114.4 x 83.9 cm
The Marquess of Northampton,4
Castle Ashby, Northampton

placed below. Like the presence of the family tomb in the church, therefore, it was surely meant to represent a sense of continuity beyond the life of the patron who commissioned it and who sometimes sat enthroned beneath it.

The pose and assertiveness of Henry VIII that Holbein created was meant to pass to his son, Edward VI, seen repeating the stance of his father in a full-length painting by William Scrots in the Royal Collection. The three-quarter length image shown here may be a companion to the portrait of his sister Elizabeth discussed earlier, since it was commissioned at the same time in 1546. A very different problem of finding the right mode of portrayal arose with the depiction of Edward's successor, Mary I. As we have already noted, Mary largely used Hans Eworth as her court painter and several images of the Queen are ascribed either to him or to his workshop. But on one occasion she was painted rather differently. This was when she was portrayed by the Flemish artist Anthonis Mor at the time of her marriage to Philip of Spain. The Mor portrait of Mary, initiated as a commission by her husband, survives in three versions. The need for continuity here lies not in an English but in a continental context. Mor's work is concerned less with showing the Queen as a Tudor sovereign than as a royal Hapsburg consort. Foreign observers would have noted that she wears the jewel that her husband gave her, and that she is posed in the way that previous Hapsburg consorts had been portrayed, by Titian among others, earlier in the century. Because this takes on board international portrait conventions, it remains a unique instance in English royal portraiture of the sixteenth

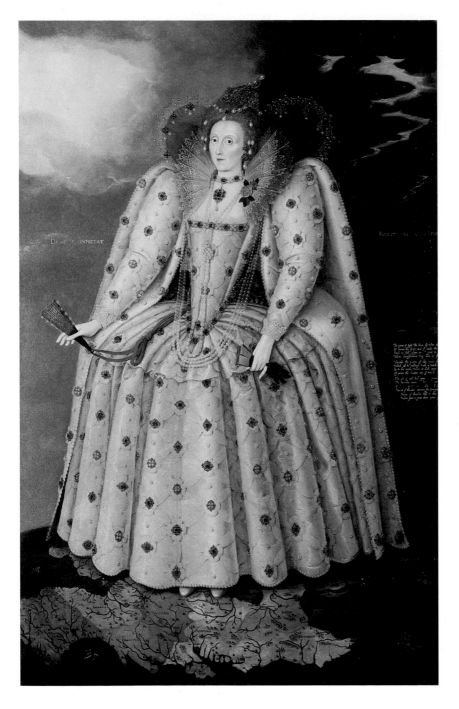

century of the figure seated in convincing three-quarter view. It is quite unlike what were to become the most familiar, icon-like images of her sister, Elizabeth.

Elizabeth's imagery is one of the most studied areas of all Renaissance portraiture. It is important here to note something of the range of portrayal and her personal involvement with decisions about it. The Queen's image had to be kept under constant surveillance. Anxiety about the spread of unauthorised images of the Queen led to the proclamation of 1563, reserving the portrayal of her to some 'coning [cunning in this sense meaning skilful] painter' and 'to prohibit all manner of other persons to draw, paynt, grave or pourtray Hir Majesties's person or visage for a time until by some perfect patron [meaning prototype] and example, the same may be by others followed'. The necessary stamp of authority led therefore to many versions of each approved image of her. Elizabeth however needed more than one kind of portrait; what we think of as the stiff, iconic image of her later years, as exemplified in the Armada portrait, or the Ditchley portrait, where any illusion of reality is sacrificed to programmatic content, had to be quite different from pictures sent earlier in her reign, for example, as part of marriage negotiations. Occasionally these modes of depiction meet, as in the *Portrait with a Sieve*, probably from the 1580s, where she is portrayed in the guise of the classical vestal virgin, Tuccia, carrying a sieve to prove her chastity, yet is posed less formally than in other portraits carrying similar complex allusions.

Other images of Elizabeth are laid out for us to read in a very straightforward manner. The imagery recording her at the time of her

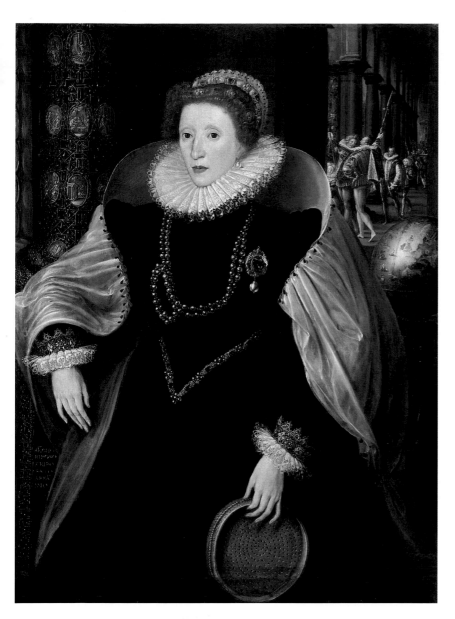

52 Marcus Gheeraerts the Younger
*Elizabeth I (The 'Ditchley' Portrait) c.*1592
Oil on canvas 241.3 x 152.4 cm
National Portrait Gallery, London

53 Quentin Metsys the Younger
*Elizabeth I (The 'Sieve' Portrait) c.*1580
Oil on canvas 124.5 x 91.5 cm
Pinacoteca Nazionale, Siena

coronation in 1559, such as the portrait now in National Portrait Gallery which may be a copy of *c.*1600, is principally an heraldic image like that on seals or official documents, though emphasis is also given to the personal traits of the dynasty for here she is displayed as the successor to her father by the prominent red hair which she inherited from him. In the *Family of Henry VIII: An Allegory of the Tudor Succession*, from the early 1570s, Elizabeth is shown as the inheritor of something more; her family's political acumen and resolution. It is believed that this picture was made to celebrate the Treaty of Blois which concluded peace with France in 1572. It was presented by the Queen to Sir Francis Walsingham who had been instrumental in the making of that treaty. Under a splendid loggia, figures of Peace and Plenty escort Elizabeth into the presence of her forbears to complete an illusion of family continuity through four reigns; a strong king, a virtuous son to that king, a zealous daughter and finally Elizabeth herself whom, as the inscription tells us 'to England's joy we see successively to hold the right, and virtues of all three'. The artist, probably Lucas de Heere, a refugee from the Netherlands, uses a series of prototypes from single portraits, including of course the Holbein image of Henry VIII, for his royal figures. So sixteenth-century viewers would have been expected to recognise content by the recognition of familiar components. Looking from figures to inscription and back again, the first viewers of this picture would have read an unambiguous affirmation of dynastic control and power.

The Tudor dynasty was often portrayed as a group of separate figures in sculpture, as in the busts now at Lumley Castle, depicted in

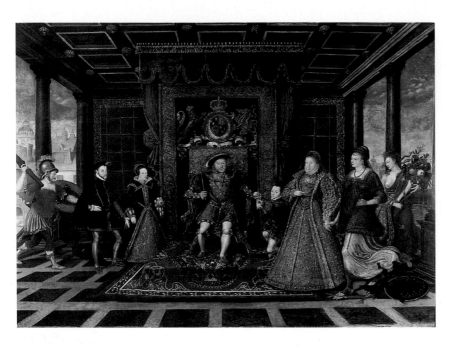

54 Attributed to Lucas de Heere
*The Family of Henry VIII: An Allegory of the Tudor Succession c.*1570
Oil on panel 131.2 x 184 cm
National Museum and Gallery, Cardiff (on loan to Sudeley Castle, Gloucestershire)

the Lumley Inventory of 1590, and on many recorded public buildings. However, it was of course as the Virgin Queen, alone because wedded to her country, that Elizabeth sought the justification of her unmarried state, a role around which myths were spun in her later years. Elaborate pageants exploring this theme were laid on for her reception on progresses around the country. In a sense, such occasions as these and her carefully timed public appearances, now recorded for us only in words since their visual apparatus has gone, are, like the great country houses built by her leading courtiers with ambitions to entertain her, all part of her 'imagery', because they are all part of a calculated projection of her unique place and role.

With the early Stuart kings, the image of monarchy was very different. There are some

links with the past for dynastic continuity between Tudors and Stuarts was important. Both Elizabeth I and James I were descended from Henry VII and in the early years of his reign James erected for his late cousin the elaborate tomb by Maximilian Colt in the north aisle of Henry VII's Chapel in Westminster Abbey. In the south aisle, he placed the tomb by Cornelius Cure of his mother, Mary, Queen of Scots. Hence Tudor and Stuart lines of descent, like a family tree, flank the common ancestor, Henry VII, buried in the main body of the Chapel. Some forms of portraiture, by their very function, were conservative in their presentation of the subject. State portraits of both James and his son Charles I, destined to hang in public rooms, necessitated the wearing of ermine and regalia as tradition demanded.

Yet in other ways royal imagery changed dramatically. Most importantly, what monarchy meant in terms of the nation over which it ruled was now different. After the union of the crowns of Scotland and England in the person of James I and VI, a new imperial iconography had to be devised; this was realised triumphantly by Rubens on the ceiling of the Banqueting House in Whitehall in the 1630s and in the imperial image of *Charles I on horseback* by Van Dyck, now in the National Gallery, with the words 'CAROLUS REX MAGNA BRITANNICA' fixed to the tree beside him. Moreover, by contrast with Elizabeth's image, both James and Charles, in different ways, encouraged new imagery of the royal family to highlight different aspects of the role of monarchy. Compared with Elizabeth, who believed in making herself visible on carefully stage-managed occasions, James saw himself as the authoritative, stern and rather remote father

55 Willem van de Passe
The Family of James I
Engraving
British Museum

figure of his country. New dynastic imagery placed him, in the prints of Willem van de Passe, at the centre of a family group arranged in such a way as to suggest, quite blatantly, religious pictures of the past. The King sits on a raised throne, like the central figure of a Catholic altarpiece, with palm-bearing angels at his feet. What is also made evident is that he is the father of a proto-European family of royalty through the marriage of his daughter Elizabeth to the Elector Palatine. A new European dimension has therefore entered British royal iconography.

Charles I was to extend the potential of family imagery in a different way, for he was to use his chief Court artist, Van Dyck, to depict him with his wife Henrietta Maria and the royal children in a state portrait that also played on the viewer's sensitivity to Charles' personal paternalism and the children's youth

and innocence. These paintings are the beginning of a long tradition of royal family groups which recurs in images of Victoria and Albert and, in recent times, those of the present royal family. They allow more informal presentation on the understanding that no observer could doubt for a moment who these people are. The informality does not threaten their dignity; the implication is that these people lead the nation not only by political example but by their virtue as members of a close family as well.

This imagery was to be well served by the new style of painting that Van Dyck brought to the Court and which we conventionally regard as the point when more sophisticated European ways of painting first came to England. But it is important to note that the style could only succeed by having a role to play and not simply because it was worth adopting for its own sake. The different political reality is perhaps the key to understanding changes in painting in the early seventeenth century. At the risk of simplifying the issue, it could be argued that the Tudors came to power through Henry VII's conquest at Bosworth Field and they retained it through their strength of purpose, political control and astuteness, virtues they variously brought to the task of rulership. For James and Charles, kingship was an innate, divine right; whether in robes of state or sitting with their family, that right to rule would shine through their demeanour. The bolted-on, agglomerative quality of Tudor image-making had to give way to a style that presented the sitter in a less fragmented fashion. Some analysis of the success of the use of an alternative style and the new images it created will form the subject of the concluding chapter.

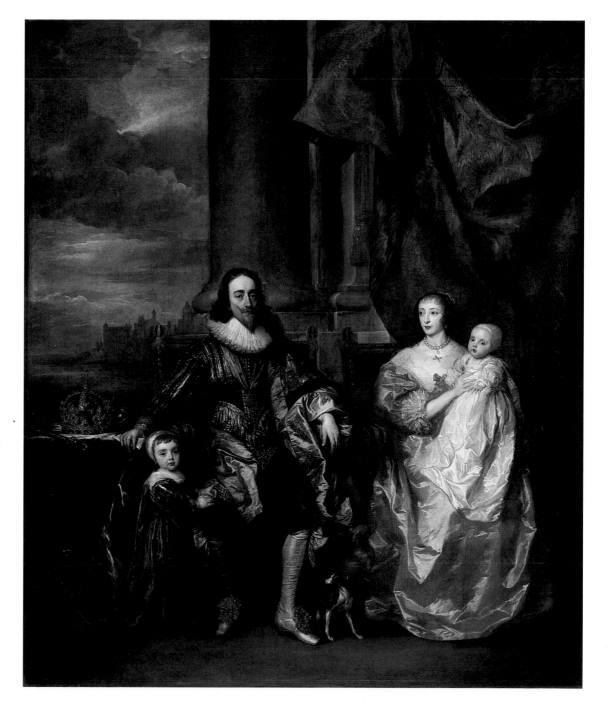

56 Anthony Van Dyck
Charles I, Henrietta
Maria and their Two
Eldest children ('The
Great Piece') 1632
Oil on canvas
302.9 x 255.9 cm
(including later
additions)
The Royal Collection. Her
Majesty The Queen

Tudor image into Stuart idealism

IT HAS BEEN the premise of this book that changes of style in painting do not come about in an orderly, chronological way, because different styles of painting can exist alongside each other, for different purposes, for different sizes and formats of picture, for different places even within the same house. It will not be surprising then that it so happens that of the three images which will be used to explore the theme of change in this chapter, the first to be discussed is essentially the most stylistically 'old-fashioned' yet may well have been the last of the three to have been painted. Nor will it surprise us that the picture's complexity of content necessitates a blend of new and old styles in order to make its point.

The Tate Gallery's life-size painting of *William Style of Langley*, by an unknown artist, is dated 1636. The subject stands in a room with an open casement window at the left and a view through an arch on to a garden at the right. In some respects this picture follows conventions different from those of the Elizabethan portrait type. There is a strong sense of perspective in the depiction of the garden. Crucially, the artist has learned from foreign conventions the trick of placing the subject between indoors and out, suggesting potential movement. William Style turns towards the opening at the right as if gesturing for us to go through it with him, his left hand poised over the transition from indoors to garden. The picture is a complex digression on the sitter's mind and thought, akin to the melancholy and ambiguous indecision we associate with some of the more romantic Jacobean miniatures such as *Lord Herbert of Cherbury*. Clues to understanding the nature of his dilemma are laid out for us like the scattered heraldry of a Tudor full-length. William Style was a lawyer who espoused Catholicism. Four years after this picture was painted he was to publish his own translation, into Latin, of a German Counter-Reformation tract. Looking across the picture for a moment as if it were a two-dimensional surface, we see that he turns his back on his earthly pursuits, his books, music, and the coat of arms which define his social position. He points in the other direction to the globe at the bottom right of the picture with its motto that tells of his desire for the spiritual life. The programme of the picture is therefore cumulative since we have to understand and dissect its iconography. Rather like the *Saltonstall Family*, we are perhaps left wondering whether the huge size of this work and its personal content really go successfully hand in hand.

Daniel Mytens' portrait of *Thomas Howard, Earl of Arundel*, on the other hand, painted in about 1618, shows a very acute matching of content, style and life-size format. Again, the sitter uses a rod as if to point but here it is not directing us to a specifically programmed meaning but rather directing our eyes to something more general, but equally illuminating about the patron's life and concerns, namely the value of his collection of antique sculpture. No aspect of the foreground of the picture distracts us from following his lead; his sober dress, his resolute stance in the chair persuade us of his single-mindedness. The Earl of Arundel was the grandson of the fourth Duke of Norfolk, whose portrait by Eworth we looked at earlier. He was restored in blood in 1604 but remained something of an outsider to the English aristocracy, even though the rod he holds is the Earl Marshal's baton, symbol of the hereditary office at Court held by the

head of the Howard family which was restored to him. He spent much time in Italy and was responsible for gathering the earliest of a group of distinguished collections of paintings and sculpture that became the model of taste for those of the Duke of Buckingham and Charles I. In pointing to his gallery of classical sculpture, housed in Arundel House overlooking the Thames in London, it is as if he silently and with great conviction instructs us to look and learn from this weight of classical example, not in moralistic terms but as works of art to be admired. Since Arundel has become so crucial a figure in histories of art of this period for his encouragement of Inigo Jones and all that he was to transform about the visual culture of the early Stuart court, we cannot help feeling that this picture would have to have been invented if it did not exist. But let us end our look at this image and pass on to our last by quoting Clarendon's description of Arundel because it seems almost to be speaking of this portrait in the way it illumines the mind of the sitter, his education and how these emerged in his very appearance. Arundel, he says, had 'the appearance of a great man, which he preserved in gate, and motion. He wore and affected a Habit very different from that of the time, such as men

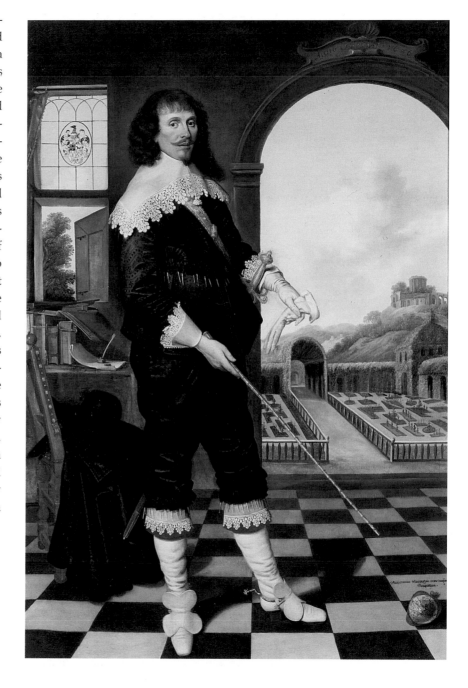

57 British School
William Style of Langley 1636
Oil on canvas 205.1 x 135.9 cm
Tate Gallery, London

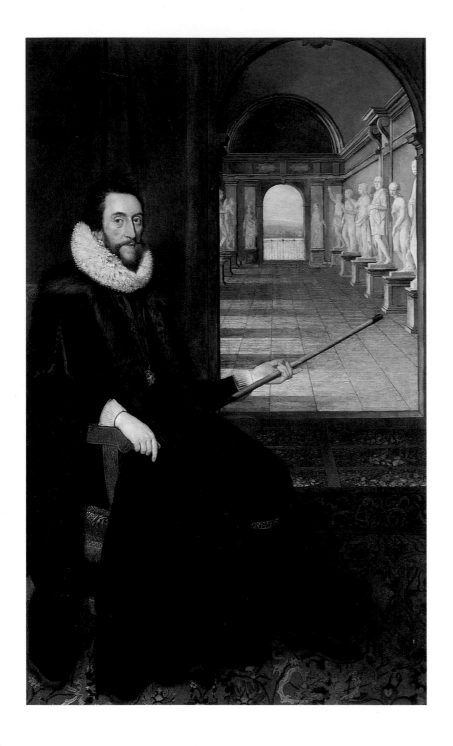

only behold in the Pictures of the most considerable men; all which drew the eyes of most and the reverence of many towards him as the Image and Representative of the Primitive Nobility, and Native Gravity of the Nobles when they had been most Venerable'.

If we can see something of 'Native Gravity' in this portrait, this gives us a clue to understanding a fundamental shift in the notion of portrait-making that separates the representations of the courtiers of Elizabeth from those of Charles I. In Van Dyck's *Portrait of a Lady of the Spencer family* of the mid-1630s, now in the Tate Gallery, the first thing we should note about the fluency of style that Van Dyck brings to his painting is the help he is given to the revolution in fashion that has taken place. By comparison with the ruffs and stiff collars, the elaborate headgear and the stiff costumes of the Elizabethan and Jacobean courts, the mode of dress here has been loosened, simplified, softened in contour, matching and supporting the looseness and opening up of the brushwork. Her incipient move forwards through the generalised landscape she inhabits is eased, made convincing by these means. And where now is all the information about her for the sake of identification? It is not totally absent, for the dog and lizard are believed to be tokens of fidelity and may represent her recent marriage, though they are painted in quite a generalised way. At a later date, she was given

58 Daniel Mytens
*Thomas Howard, Earl of Arundel c.*1618
Oil on canvas 207 x 127 cm
National Portrait Gallery, London

her place in the 'dynasty' of the Spencers on display in the family home of Althorp by a new, and still surviving, frame which is in the same style as that of several other portraits across several generations. But the message we get here is not one of social standing from heraldry, complex patterns on costume fabrics or inscriptions; unreal, flat surfaces around the sitter which in Tudor times carried these messages here give way to a naturalistic setting. It is as if we are expected to understand this woman's rank not by a complex range of visual sign-language but by her bearing and sense of self-possession. Some of the old polarities suggested in this book remain at issue here. Arundel, by his learning, travel and purchasing power could cultivated his sense of identity through the fruits of his activities but what, we might wonder, could this woman have done with her life? Ironically therefore, though we may feel, as modern viewers, that we can empathise and relate to her more easily than to earlier portraits behind their barricades of fabrics, chairs and curtains, her anonymity and the lack of obvious clues in the picture make her in some ways more unknowable than her forbears, and therefore more remote from us. The change of style at Van Dyck's hands and the resulting dismemberment of the 'Tudor image' has left us with a different set of questions.

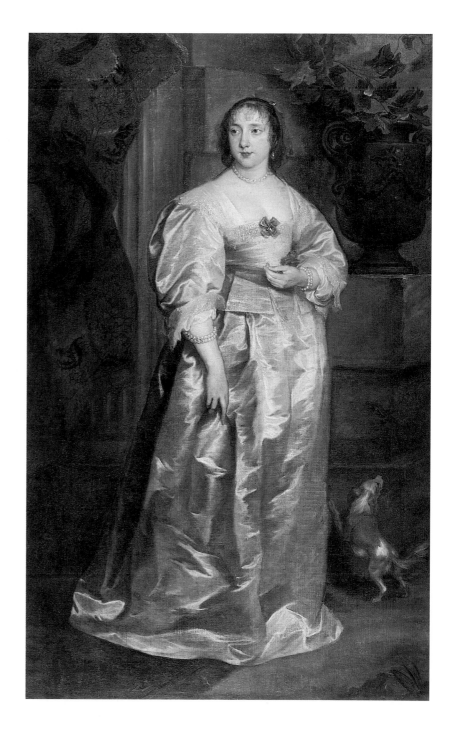

59 Anthony Van Dyck
A Lady of the Spencer Family c.1633-8
Oil on canvas 207.6 x 127.6 cm
Tate Gallery, London

BIBLIOGRAPHY

Anglo, Sydney, *Images of Tudor Kingship*, London, 1992.

Aston, Margaret, *The King's Bedpost. Reformation and Iconography in a Tudor Group Portrait*, Cambridge, 1993.

Denvir, Bernard, *From the Middle Ages to the Stuarts. Art, Design and Society before 1689* (an edited collection of useful documents), London and New York, 1988.

Duffy, Eamon, *The Stripping of the Altars. Traditional Religion in England 1400-1580*, London, 1992.

Edmond, Mary, *Hilliard and Oliver. The lives and works of two great miniaturists*, London, 1983.

Foister, Susan, 'Paintings and other works of art in sixteenth-century English inventories', *Burlington Magazine*, vol. CXIII, 1981, pp.273-82.

Foister, Susan, *Drawings by Holbein from the Royal Library, Windsor Castle*, London, 1983.

Gent, Lucy, *Picture and Poetry 1560-1622. Relations between Literature and the Visual Arts in the English Renaissance*, Leamington Spa, 1981.

Gent, Lucy and Llewellyn, Nigel (eds.), *Renaissance Bodies. The Human Figure in English Culture c. 1540-1660*, London, 1990.

Hearn, Karen, *Dynasties*, exh. cat., Tate Gallery, London, 1995.

Hilliard, Nicholas, *The Arte of Limning*, eds. R.K.R. Thornton and T.G.S. Cain, Carcanet Press, 1992.

King, John N., *Tudor Royal Iconography. Literature and Art in an age of religious crisis*, Princeton, 1989.

Llewellyn, Nigel, *The Art of Death. Visual Culture in the English Death Ritual c.1500-c.1800*, London, 1991.

Millar, Oliver, *Tudor, Stuart and Early Georgian Pictures in the Collection of Her Majesty The Queen*, London, 1963.

Rodriguez-Salgado, M.J. *Armada 1588-1988*, exh. cat., National Maritime Museum, Greenwich, 1988.

Rowlands, John, *Holbein. The Paintings of Hans Holbein the Younger*, Oxford, 1986.

Starkey, David (ed.) *Henry VIII. A European Court in England*, exh. cat., National Maritime Museum, Greenwich, 1991.

Strong, Roy, *The English Icon*, London, 1969

Strong, Roy, *Artists of the Tudor Court. The Portrait Miniature Rediscovered*, Victoria and Albert Museum, London, 1983.

Strong, Roy, *The Cult of Elizabeth*, London, 1977.

Watt, Tessa, *Cheap Print and Popular Piety, 1550-1640*, Cambridge, 1991.

Woodall, Joanna, 'An Exemplary Consort: Anthonis Mor's Portrait of Mary Tudor' *Art History*, vol. 14, no. 2 (1991), pp.192-224

PHOTOGRAPHIC
CREDITS

The author and publishers are grateful to the following for their kind permission to reproduce photographs:

Marquess of Bath 37
The British Library 7, 8, 9, 43
British Museum 47, 55
Courtauld Institute Galleries 31
English Heritage Photographic Library 6, 28
Syndics of the Fitzwilliam Museum 40
Maurice Howard 3, 13, 14, 15, 20, 21
Jarrold Publishing 12
National Gallery 17, 24, 29
National Gallery of Art, Washington 49
National Portrait Gallery 10, 19, 26, 52, 58
National Museum and Gallery, Cardiff 54
National Trust Photo Library 5, 44
Pinacoteca Nazionale, Siena 53
The Rt. Hon. Earl of Powis 42
Private Collection 25, 27, 35, 41, 51
Royal Commission of Historical Monuments (RGHME Crown Copyright) back cover
The Royal Collection Her Majesty The Queen 4, 18, 39, 48, 50, 56
Earl of Scarborough 2
Sidney Sussex College (photo Tate Gallery) 34
Tate Gallery 1, 11, 16, 22, 23, 30, 32, 33, 38, 46, 57, 59
Victoria and Albert Museum 36, 40b